Cool Restaurants
Milan

teNeues

Imprint

Editor:	Cynthia Reschke
Photography:	Yael Pincus
Introduction text:	Borja de Miguel
Copyediting:	Susana González
Layout & Pre-press:	Emma Termes Parera
Translations:	James Stewart (English), Anette Hilgendag (German) Marion Westerhoff (French), Eva Raventós (Spanish) Sara Tonelli (Italian)

Produced by Loft Publications
www.loftpublications.com

Published by teNeues Publishing Group

teNeues Publishing Company
16 West 22nd Street, New York, NY 10010, USA
Tel.: 001-212-627-9090, Fax: 001-212-627-9511

teNeues Book Division
Kaistraße 18
40221 Düsseldorf, Germany
Tel.: 0049-(0)211-994597-0, Fax: 0049-(0)211-994597-40

teNeues Publishing UK Ltd.
P.O. Box 402
West Byfleet
KT14 7ZF, Great Britain
Tel.: 0044-1932-403509, Fax: 0044-1932-403514

teNeues France S.A.R.L.
4, rue de Valence
75005 Paris, France
Tel.: 0033-1-55 76 62 05, Fax: 0033-1-55 76 64 19

www.teneues.com

ISBN: 3-8238-4587-X

© 2004 teNeues Verlag GmbH + Co. KG, Kempen

Printed in Germany

Bibliographic information published by Die Deutsche
Bibliothek. Die Deutsche Bibliothek lists this
publication in the Deutsche Nationalbibliografie;
detailed bibliographic data is available in the Internet
at http://dnb.ddb.de.

Contents	Page

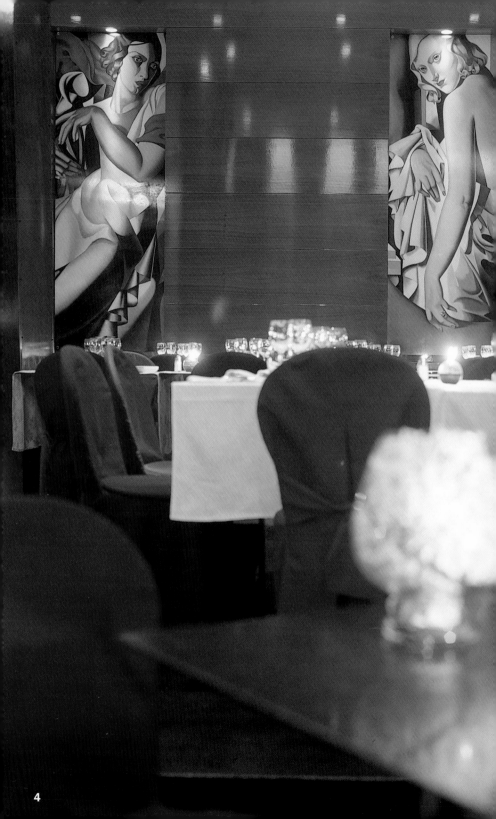

Introduzione

Senza dubbio Milano è oggi sinonimo di moda, design e arte. Questa città del Nord Italia – centro industriale, commerciale ed economico del paese – ospita gli eventi internazionali più importanti in questo ambiti, richiamando migliaia di turisti e professionisti in ogni periodo dell'anno. Inoltre, grazie alla sua vita intensa e sofisticata, che sa trasformare anche lo shopping e una semplice cena in un evento indimenticabile, Milano si afferma come una delle maggiori metropoli al mondo, al pari di Parigi, New York, Londra o Berlino.

La tradizione ricopre di certo un ruolo fondamentale nella cultura italiana. Le presenza a Milano di diverse civiltà – da quella celtica, che la fondò, fino a quella romana, francese, svizzera, austriaca, spagnola... – ha fatto sì che la città assumesse gusti e costumi molto eterogenei nel corso della sua storia, che l'hanno dotata di una grande personalità e l'hanno resa un luogo irripetibile. I suoi abitanti, allegri e ospitali, sono conosciuti in tutto il mondo per la simpatia e la raffinata eleganza. A volte l'intensa attività quotidiana immerge Milano – invasa e ricostruita infinite volte, luogo di armoniosa convivenza tra antico e moderno – in un caos apparente, proprio delle città latine. A Milano si può trovare tutto il possibile: dalle più classiche espressioni dell'arte europea – i dipinti di Leonardo Da Vinci, le sculture di Michelangelo e il Duomo, il quarto tempio cristiano più grande al mondo – fino alle tendenze più attuali nel design, l'architettura e la moda, visibili nei negozi, club, bar e ristoranti.

Dal punto di vista gastronomico, Milano offre – come tutto il resto d'Italia – delle possibilità infinite, anche se la varietà dei suoi piatti tradizionali viene spesso messa in ombra dalla pasta e dalla pizza, i due piatti più tipici. L'offerta culinaria di questo paese saprà sorprendere tutti gli amanti della buona cucina – a partire dai diversi tipi di formaggio come il parmigiano reggiano, il grana padano e il gorgonzola, passando per gli insaccati come lo zampone e il culatello, fino alla carne, il pesce, senza dimenticare i dolci, i gelati, i vini e i liquori. Per questo, Milano non fa che confermare ogni giorno un destino gastronomico – ma anche culturale, turistico e professionale – difficilmente superabile, che non deluderà il visitatore.

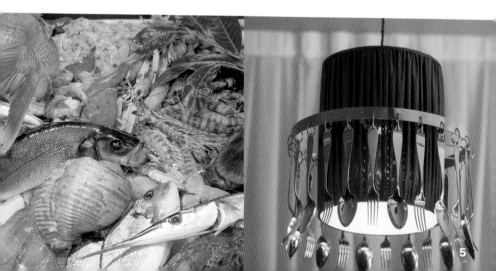

Introduction

Milan nowadays, is without a doubt a city synonymous with fashion, design and art. This northern Italian city—an industrial, commercial and economic center of the country—hosts the most important international events in these sectors, and for these reasons, attracts thousands of tourists and professionals, throughout all the seasons of the year. Furthermore due to the intense and sophisticated lifestyle, going shopping or simply going for dinner becomes a show in itself. It can be said that Milan is one of the great metropolises of the world, comparable to Paris, New York, London or Berlin.

If there is one aspect that is noteworthy of Italian culture, it is tradition. The successive presence of diverse civilisations in Milan, from the Celts who founded the city to the Romans, French, Swiss, Austrians, and Spanish ... has resulted in a city, that throughout its history, has adopted varied tastes and customs which have given it great personality and have converted it into an unforgettable place. Its people, cheerful and hospitable, are known the world over for their friendly nature and elegance. The intense daily activity sometimes submerges the city in an apparent chaos, very common of Latin cities. It is a city which has been invaded, reconstructed infinite times and where the old and the modern coexist in complete harmony. In Milan it is possible to find almost everything; from Leonardo Da Vinci's paintings, Michelangelo's sculptures, or the Duomo cathedral—the fourth largest Christian temple—to the latest trends in design, architecture and fashion in its shops, clubs, bars and restaurants.

Gastronomically Milan, like much of Italy, offers endless of possibilities. The variety of its traditional dishes is very rich but is often eclipsed by its typical pasta and pizzas. However its range of foods should not be forgotten; from its many cheeses; parmigiano reggiano, grana padano, gorgonzola, its sausages; zampone, culatello, to its meats and fish, and not to mention, its desserts, ice creams, wines and liquors. The culinary possibilities of this country surprise and enamour all fine foods lovers. For this reason Milan also conforms to being a gastronomic destination, as well as cultural, touristic, and professional—difficult to beat and which seldom disappoints its visitors.

Einleitung

Mailand steht heute ohne Zweifel für Mode, Design und Kunst. Die Stadt im Norden Italiens ist ein bedeutendes Industrie-, Einkaufs- und Wirtschaftszentrum des Landes und Schauplatz wichtiger Veranstaltungen der genannten Bereiche. Die Stadt zieht das ganze Jahr über Tausende von Geschäfts- und Privatreisenden an. Das intensive, mondäne Leben, bei dem bereits ein Shopping-Ausflug oder ein Abendessen ein Erlebnis sind, macht Mailand zu einer der großen internationalen Metropolen, auf einer Ebene mit Paris, New York, London und Berlin.

Eine wichtige Rolle in der italienischen Kultur spielt die Tradition. Die Anwesenheit verschiedener Völker im Laufe der Stadtgeschichte – angefangen von den Kelten, von denen die Stadt gegründet wurde, über Römer, Franzosen, Schweizer, Österreicher, Spanier – hat dazu geführt, dass die Stadt unterschiedliche Vorlieben und Traditionen entwickelt hat, die ihr einen besonderen Charakter verleihen und sie zu einem unvergleichlichen Reiseziel machen. Die herzlichen und gastfreundlichen Mailänder sind in der ganzen Welt bekannt für ihre sympathische Art und ihre Eleganz. Die intensiven Alltagsaktivitäten scheinen die Stadt im Chaos versinken zu lassen, wie es für südländische Städte typisch ist. Mailand wurde unendlich viele Male erobert und neu erbaut, und Altes und Neues leben hier in perfekter Harmonie zusammen. Diese Stadt bietet dem Besucher von jedem etwas: Von klassischer europäischer Kunst – wie Werken von Leonardo Da Vinci oder Michelangelo oder dem Duomo, dem viertgrößten Gotteshaus der Welt – bis hin zu den neusten Tendenzen in Design, Architektur und Mode, die sich in den Geschäften, Clubs, Bars und Restaurants zeigen.

Auf gastronomischem Gebiet bietet Mailand wie das übrige Italien auch ein nahezu unendliches Angebot. Die für Italien so typischen Nudel- und Pizzagerichte stellen zwar gelegentlich die Vielfalt an traditionellen Gerichten ein wenig in den Schatten, aber die reiche Auswahl an Käsesorten wie Parmigiano Reggiano, Grana Padano, Gorgonzola, Wurstarten wie Zampone oder Culatello, Fleisch- und Fischspezialitäten, Desserts, Eissorten, Weinen und Likören wird den Besucher immer wieder aufs Neue überraschen. Liebhaber guter Küche kommen hier ganz besonders auf ihre Kosten. Mailand hat neben Kultur, Sehenswürdigkeiten und Business-Angeboten auch ein gastronomisches Programm zu bieten, das nicht so leicht zu übertreffen ist und den Besucher sicher begeistern wird.

Introduction

Aujourd'hui, on ne peut évoquer Milan sans parler de mode, design ou art. Cette ville du Nord de l'Italie – cœur industriel, commercial et économique du pays – accueille les plus grands évènements internationaux dans ces domaines. C'est toute l'année et en toute saison un pôle d'attraction pour touristes et professionnels. Qui plus est, riche d'une vie intense et raffinée où faire des emplettes ou tout simplement aller dîner est toujours synonyme de spectacle, Milan est réellement une des grandes métropoles du monde, au même titre que Paris, New York, Londres ou Berlin.

La culture italienne a été marquée du sceau de la tradition. En effet, Milan, à la croisée de civilisations successives – depuis les Celtes, ses fondateurs, jusqu'aux Romains, Français, Suisses, Autrichiens et Espagnols etc...– s'est enrichie tout au long de son histoire de divers goûts et coutumes lui forgeant un caractère unique et la façonnant en un site exceptionnel. Les Milanais, joyeux et hospitaliers, sont réputés dans le monde entier pour leur gentillesse et leur élégance. L'intensité de la vie quotidienne semble parfois plonger dans un chaos apparent à l'instar de toute ville latine et surtout de toute cité détruite et reconstruite indéfiniment où l'ancien et le moderne se côtoient harmonieusement. Il est vrai que Milan offre tous les styles d'art : des modèles de l'art européen le plus classique – telles les peintures de Léonard de Vinci, les sculptures de Michel-Ange ou encore la cathédrale Duomo, le quatrième plus grand temple chrétien du monde – aux tendances les plus actuelles du design, de l'architecture, et de la mode qui se reflètent dans les boutiques, les clubs, les bars et les restaurants.

Sur le plan de la gastronomie, Milan – comme toute l'Italie – offre un éventail de possibilités infinies ou presque. La variété de ses plats traditionnels est d'une richesse souvent éclipsée par les pâtes et pizzas plus typiques. Mais n'oublions pas que grâce à une palette allant des différentes sortes de fromages – parmigiano reggiano, grana padano, gorgonzola...– en passant par la charcuterie – zampone, culatello...– jusqu'aux viandes et poissons – sans oublier desserts, glaces, vins et liqueurs, tous les délices culinaires possibles du pays surprendront et feront fondre de plaisir les amoureux de la bonne cuisine. C'est ce qui fait de Milan une destination gastronomique incontournable – sans parler de l'offre culturelle, touristique et professionnelle – qui ne décevra pas le visiteur.

Introducción

Decir Milán hoy es, sin duda, decir moda, diseño y arte. Esta ciudad del norte de Italia –centro industrial, comercial y económico del país– alberga los encuentros internacionales más importantes en estos ámbitos, motivo por el que atrae a miles de turistas y profesionales durante todas las estaciones del año. Además, la intensidad y sofisticación de su estilo de vida hace que ir de compras o a cenar resulte un espectáculo, y convierte Milán en una de las grandes metrópolis del mundo, comparable a París, Nueva York, Londres o Berlín.

Si hay algo que pesa en la cultura italiana es la tradición. La diversidad de pueblos que han habitado Milán –desde los celtas, que la fundaron, hasta los romanos, franceses, suizos, austriacos, españoles...– ha hecho que esta ciudad haya ido tomando, a lo largo de su historia, gustos y costumbres muy variados que la han dotado de una gran personalidad y la han convertido en un lugar irrepetible. Sus gentes, alegres y hospitalarias, son conocidas en el mundo entero por su simpatía y elegancia. La intensa actividad diaria a veces sumerge en un aparente caos, muy propio de las ciudades latinas, a una ciudad que ha sido invadida y reconstruida infinidad de veces y en la que lo antiguo y lo moderno conviven en total armonía. Y es que en Milán es posible encontrar de todo: desde las muestras del arte europeo más clásico –pinturas de Leonardo Da Vinci, esculturas de Miguel Ángel o la catedral del Duomo, el cuarto templo cristiano más grande del mundo– hasta las tendencias más actuales en diseño, arquitectura y moda en sus tiendas, clubs, bares y restaurantes.

Desde el punto de vista gastronómico, Milán –al igual que toda Italia– ofrece posibilidades casi infinitas. La variedad de sus platos tradicionales es de una riqueza que muchas veces queda eclipsada por su típica pasta y pizza. Pero no hay que olvidar que desde los diferentes tipos de quesos –parmigiano reggiano, grana padano, gorgonzola...– o embutidos –zampone, culatello...– hasta las carnes y pescados –sin olvidar los postres, helados, vinos y licores–, las posibilidades culinarias de este país sorprenderán y enamorarán a todos los amantes de la buena cocina. Por ello, Milán conforma actualmente un destino gastronómico –aunque también cultural, turístico y profesional– difícilmente superable que no defraudará al visitante.

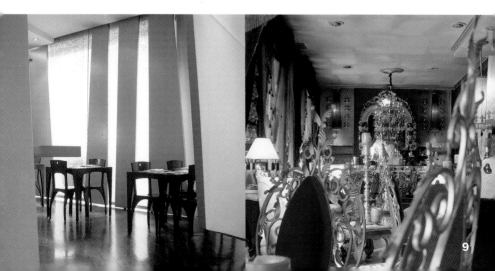

10 Corso Como Cafe Bar

Design: Kris Ruhs I Chef: Celestino Meok

Corso Como 10 I 20154 Milan
Phone: +39 02 29013581
www.10corsocomo.com
Subway: Garibaldi
Opening hours: Tue–Sun 10:30 am to 2 am, Mon 3 pm to 2 am
Average price: € 20
Cuisine: Cocktail bar
Special features: Bar only; nice and cosy atmosphere with soft music, very green,
surrounded by plants

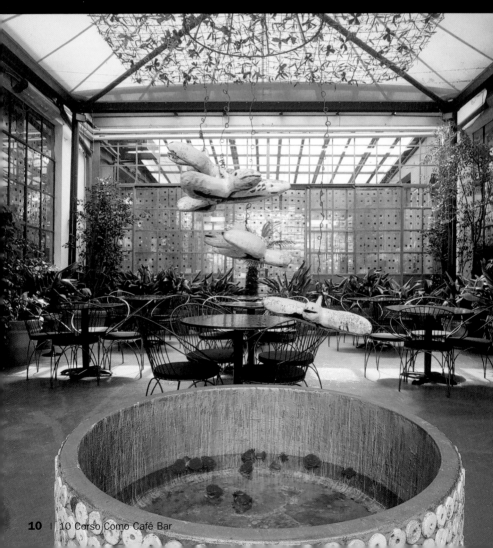

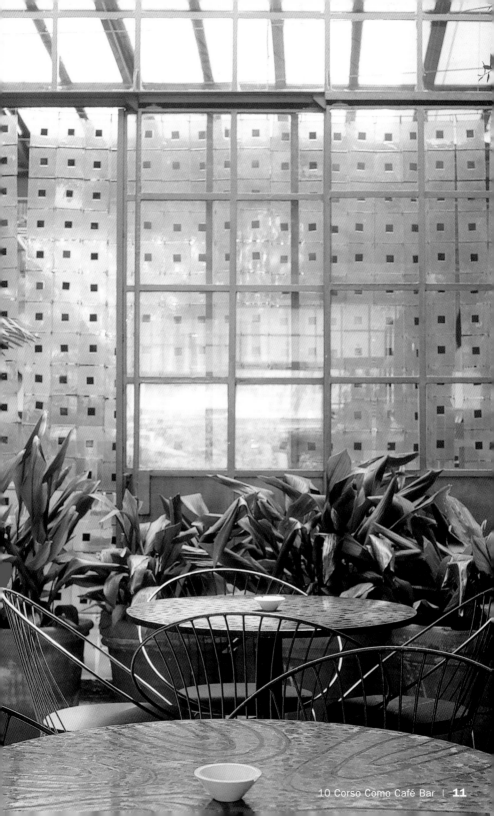

Pimm's-Ginger Ale

40 ml di liquore Pimm's
120 ml di Ginger Ale
1 fetta di limone
1 fetta di arancia
1 fragola
1 ciliegia
Foglie di menta

Mettere il liquore Pimm's e il Ginger Ale in uno shaker e agitare. Servire con ghiaccio e decorare con le frutte e le foglie di menta.

40 ml Pimm's liqueur
120 ml Ginger Ale
1 lemon slice
1 orange slice
1 strawberry
1 cherry
Mint leaves

Fill Cocktail mixer with Pimm's liqueur and Ginger Ale and shake. Serve with ice and decorate with the fruit and the mint leaves.

40 ml Pimm's Likör
120 ml Ginger Ale
1 Zitronenscheibe
1 Orangenscheibe
1 Erdbeere
1 Kirsche
Minzblätter

Pimm's Likör und Ginger Ale in einen Cocktail-shaker geben und schütteln. Mit Eis servieren und mit den Früchten und Minzblättern garnieren.

40 ml de liqueur de Pimm's
120 ml de Ginger Ale
1 rondelle de citron
1 rondelle d'orange
1 fraise
1 cerise
Feuilles de menthe

Dans un shaker, mettre la liqueur de Pimm's, le Ginger Ale et bien agiter. Servir avec des glaçons et décorer de fruits et feuilles de menthe.

40 ml de licor Pimm's
120 ml de Ginger Ale
1 rodaja de limón
1 rodaja de naranja
1 fresa
1 cereza
Hojas de menta

Introducir el licor Pimm's y el Ginger Ale en una coctelera y agitar. Servir con hielo y decorar con las frutas y las hojas de menta.

10 Corso Como Cafe Restaurant

Design: Kris Ruhs I Chef: Celestino Meok

Corso Como 10 I 20154 Milan
Phone: +39 02 29013581
www.10corsocomo.com
Subway: Garibaldi
Opening hours: Tue–Sun 10:30 am to 2 am, Mon 3 pm to 2 am
Average price: € 70 – € 80
Cuisine: Fusion Italian and international
Special features: On Saturday and Sunday an American style brunch is served until 2 pm

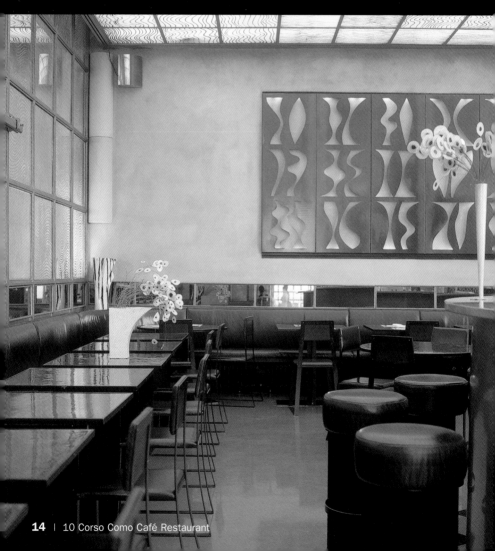

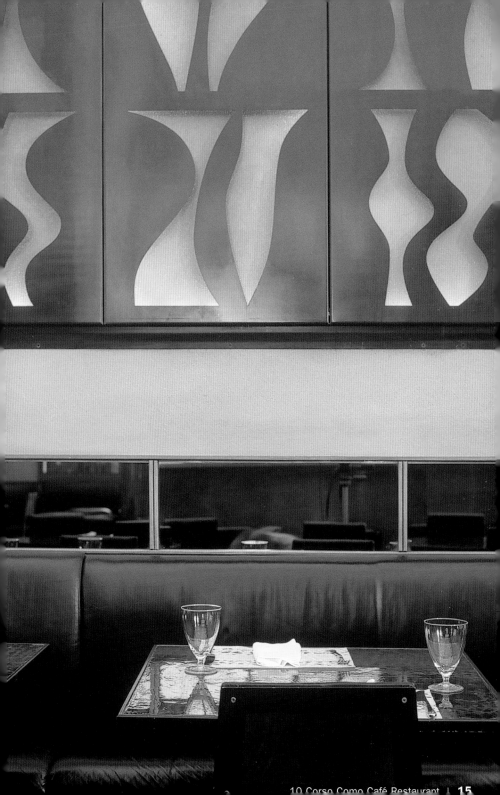

Filetto di tonno

al sesamo

Tuna Fillet with Sesame
Tunfischfilet mit Sesam
Filets de thon au sésame
Filete de atún al sésamo

1 filetto di tonno spesso di 300 g
100 g di sesamo
Olio di oliva extravergine
Sale
Wasabi marinato
Salsa di soja
Essenza di cipollotti
1 foglia di banano
Erba cipollina

Salare il filetto di tonno su entrambi i lati e rigirarlo più volte nel sesamo. Scaldare l'olio in un tegame piccolo e dorare leggermente il filetto. Impiattamento: Tagliare il filetto in fette di 1 cm di spessore per ottenere una forma geometrica e disporle in un piatto sopra la foglia di banano. Accompagnare con wasabi marinato, salsa di soja e essenza di cipollotti. Decorare ogni pezzo con erba cipollina sminuzzata.

1 thick tuna fillet (10 1/2 oz)
3 1/2 oz sesame
Extra virgin olive oil
Salt
Marinated wasabi
Soy sauce
Spring onion essence
1 banana leaf
Chives

Salt the fillet on both sides and dip in plenty of sesame. Heat the oil in small frying pan and lightly brown the fillet.
To serve: Cut the fillet into 0.5 in. thick slices to create a geometric shape and arrange on the banana leaf. Accompany with marinated wasabi, soy sauce and spring onion essence and decorate each slice with finely chopped chives.

1 dickes Tunfischfilet (300 g)
100 g Sesam
Natives Olivenöl Extra
Salz
Marinierter Wasabi
Sojasauce
Frühlingszwiebelessenz
1 Bananenblatt
Schnittlauch

Das Tunfischfilet von beiden Seiten salzen und mit reichlich Sesam panieren. Öl in einer kleinen Pfanne erhitzen und das Filet leicht goldbraun braten.
Serviervorschlag: Das Filet in 1 cm dicke Scheiben schneiden, um eine geometrische Form zu bekommen. Die Stücke auf das Bananenblatt auf einen Teller legen. Mit mariniertem Wasabi, Sojasauce und Frühlingszwiebelessenz servieren. Jedes Filetstück mit gehacktem Schnittlauch garnieren.

1 filet de gros thon de 300 g
100 g de sésame
Huile d'olive extra-vierge
Sel
Wasabi mariné (raifort japonais)
Sauce de soja
Essence d'onion tendre
1 feuille de bananier
Ciboulette

Saler le filet de thon des deux côtés et le retourner dans le sésame. Faire chauffer de l'huile dans une petite poêle et y faire dorer légèrement le filet.
Service : Couper le filet en tranches de 1 cm d'épaisseur pour obtenir une forme géométrique et les disposer dans une assiette sur la feuille de bananier. Agrémenter de wasabi mariné, de sauce de soja et d'essence d'onion tendre. Décorer chaque morceau de ciboulette émincée.

1 filete de atún grueso de 300 g
100 g de sésamo
Aceite de oliva extravirgen
Sal
Wasabi marinado
Salsa de soja
Esencia de cebolleta
1 hoja de platanero
Cebollino

Salar el filete de atún por ambos lados y rebozarlo abundantemente en sésamo. Calentar aceite en una sartén pequeña y dorar ligeramente el filete.
Emplatado: Cortar el filete en lonchas de 1 cm de grosor para obtener una forma geométrica y disponerlas en un plato sobre la hoja de platanero. Acompañar con wasabi marinado, salsa de soja y esencia de cebolleta. Decorar cada pieza con cebollino picado.

Café Atlantique

Design: Fabio Novembre

Viale Umbria 42 | 20135 Milan
Phone: +39 02 55193906
www.cafeatlantique.com
Subway: Lodi
Opening hours: Dinner, 8:30 pm to 11:30 pm; discotheque, 11:30 pm to 4 am;
Sunday brunch, 12.30 pm to 4 pm; happy hour, 7 pm to 10:30 pm
Average price: € 14 – € 18
Cuisine: Mediterranean eclectic cuisine
Special features: 1.200 m², also available for private parties and special events

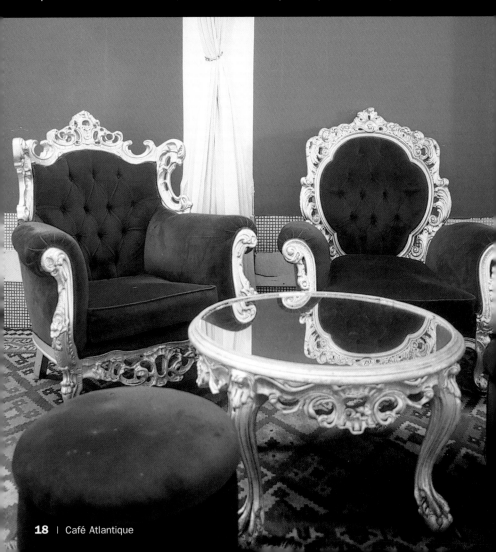

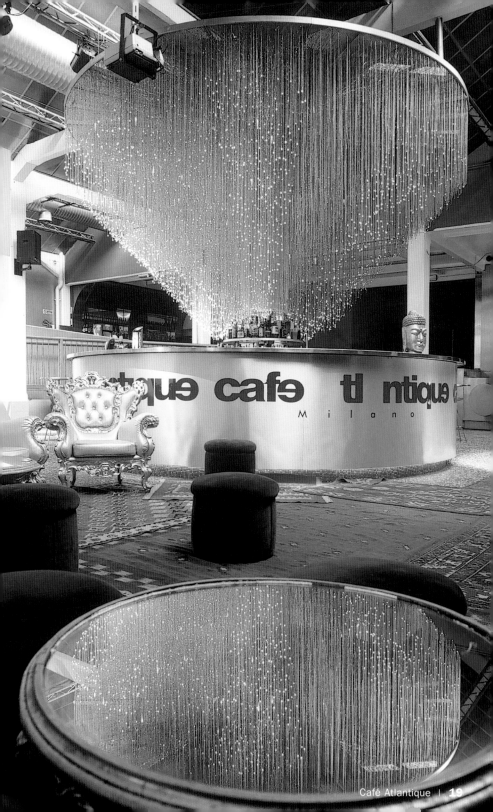

Cocktail Atlantico

60 ml di gin
60 ml di Cointreau
60 ml di Blue Curaçao
20 ml di succo d'ananas
2 gocce di succo di limone

Mettere tutti gli ingredienti in uno shaker e agitare; servire in un bicchiere grande con ghiaccio e decorare con frutta fresca di stagione e un po' di menta.

60 ml gin
60 ml Cointreau
60 ml Blue Curaçao
20 ml pineapple juice
2 drops of lemon juice

Fill a cocktail shaker with all the ingredients and shake, serve in a large glass with ice and decorate with seasonal fresh fruit and a little mint.

60 ml Gin
60 ml Cointreau
60 ml Blue Curaçao
20 ml Ananassaft
2 Tropfen Zitronensaft

Alle Zutaten in einen Cocktailshaker geben und
schütteln. In einem großen Glas mit Eis servie-
ren und mit frischen Früchten der Saison und et-
was Minze garnieren.

60 ml de gin
60 ml de Cointreau
60 ml de Curaçao bleu
20 ml de jus d'ananas
2 gouttes de jus de citron

Mettre tous les ingrédients dans un shaker et
bien agiter. Servir dans un grand verre avec des
glaçons et décorer de fruits frais de saison et de
quelques feuilles de menthe.

60 ml de ginebra
60 ml de Cointreau
60 ml de Blue Curaçao
20 ml de zumo de piña
2 gotas de zumo de limón

Introducir todos los ingredientes en una cocte-
lera y agitar; servir en un vaso grande con hielo
y decorar con fruta fresca de temporada y un
poco de menta.

Chandelier Mood & Food

Design: Antonio Coppola | Chef: From Sergio Mei's school

Via Broggi 17 | 20129 Milan
Phone: +39 02 20240458
www.chandelier.it
Subway: Lima
Opening hours: Mon–Sat 8 pm to 2 am
Average price: € 80 – € 100
Cuisine: Mediterranean and eclectic
Special features: Saturday house music with dance floor

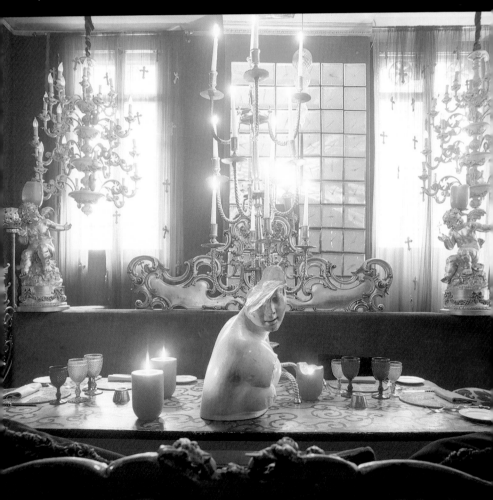

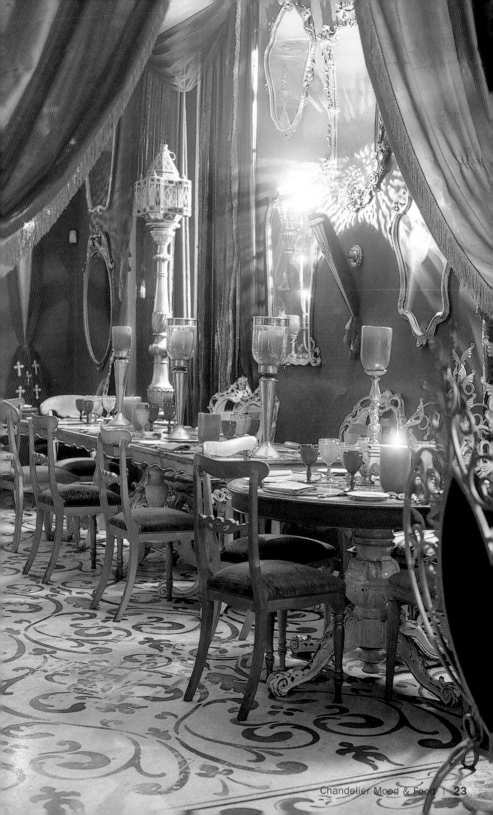

Spaghetti
al nero di seppia

Black Spaghetti
Schwarze Spaghetti
Spaghettis noirs
Espaguetis negros

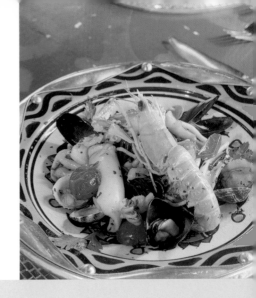

500 g di spaghetti
100 g di cozze
1 seppia
100 g di vongole
400 g di scampi
Olio
Sale
Pepe
Pomodori ciliegina
Vino bianco
Prezzemolo
Basilico

Pulire le cozze e le vongole in abbondante acqua per togliere ogni residuo di sabbia. Saltarle in un tegame insieme agli scampi. In un tegame a parte, unire il tutto alla seppia, precedentemente pulita e tagliata in pezzi abbastanza grandi. Mescolare il tutto e unire il vino bianco, aggiungere successivamente il sale, il pepe, i pomodori e una foglia di basilico fresco.
Cuocere gli spaghetti la metà del tempo necessario e terminare la cottura nel tegame insieme alla salsa. Lasciare al dente. Accompagnare con una foglia di prezzemolo.

1 lb spaghetti
3 1/2 oz mussels
1 cuttlefish
3 1/2 oz clams
14 oz Dublin Bay prawns
Oil
Salt
Pepper
Cherry tomato
White wine
Parsley
Basil

Clean the mussels and clams with plenty of water to wash off any remaining sand. Sauté together with the prawns in a frying pan. Do the same in another frying pan with the previously washed and cut large pieces of cuttlefish. Mix it all with the white wine, followed by salt, pepper and tomatoes and fresh leaf of basil.
Cook the spaghetti for half the required time and finish cooking in the frying pan in the sauce until they are al dente. Decorate with parsley.

500 g Spaghetti
100 g Miesmuscheln
1 Sepia (Tintenfisch)
100 g Venusmuscheln
400 g Kaisergranate
Öl
Salz
Pfeffer
Cherry-Tomaten
Weißwein
Petersilie
Basilikum

Miesmuscheln und Venusmuscheln mit reichlich Wasser säubern und restlichen Sand entfernen. Zusammen mit den Kaisergranaten in einer Pfanne anbraten. Den Tintenfisch säubern und in große Stücke schneiden und in einer separaten Pfanne anbraten. Alles vermischen und den Weißwein dazugeben, danach mit Salz und Pfeffer würzen und die Tomaten und ein Blatt frisches Basilikum dazugeben.
Die Spaghetti die Hälfte der erforderlichen Zeit kochen und in der Pfanne mit der Sauce fertig kochen, bis die Nudeln al dente sind. Mit einem Blatt Petersilie garnieren.

500 g de spaghettis
100 g de moules
1 sèche
100 g de petites clovisses
400 g de langoustines
Huile
Sel
Poivre
Tomates cerise
Vin blanc
Persil
Basilic

Nettoyer les moules et les laver à grande eau pour ôter le sable restant. Les faire sauter dans une poêle avec les langoustines. Prendre une autre poêle et procéder de même avec la sèche, préalablement nettoyée et coupée en gros morceaux. Réunir tous les ingrédients et ajouter le vin blanc, ensuite le sel, le poivre, la tomate et une feuille de basilic frais.
Cuire les spaghettis à moitié et terminer la cuisson « al dente » dans la poêle avec la sauce. Agrémenter d'une feuille de persil.

500 g de espaguetis
100 g de mejillones
1 sepia
100 g de chirlas
400 g de cigalas
Aceite
Sal
Pimienta
Tomates cherry
Vino blanco
Perejil
Albahaca

Limpiar los mejillones y las chirlas con abundante agua para que pierdan los restos de arena. Saltearlos junto a las cigalas en una sartén. Hacer los propio en una sartén aparte con la sepia, previamente limpiada y cortada en trozos grandes. Aunarlo todo y añadir el vino blanco, y luego la sal, la pimienta, los tomates y una hoja de albahaca fresca.
Cocer los espaguetis la mitad del tiempo necesario y acabar la cocción en la sartén junto a la salsa hasta que esté al dente. Acompañar con una hoja de perejil.

Grand Hotel | Via Manzoni 29 | 20121 Milan
Phone: +39 02 72314646
www.grandhoteletdemilan.it
Subway: Montenapoleone
Opening hours: Mon–Sun 7:30 pm to 11 pm
Average price: € 60 – € 80
Cuisine: Italian innovative kitchen
Special features: Don Carlos restaurant has been called so in honour of Maestro
Giuseppe Verdi, who was a guest of the Grand Hotel for more than 20 years

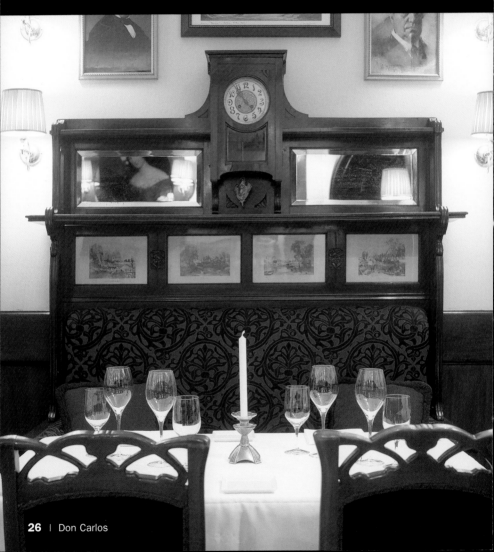

Don Carlos | **27**

Pesce spada
marinato con cipolla rossa di Tropea

Swordfish Pickled with Tropea Red Onion

Marinierter Schwertfisch mit roten Zwiebeln

Espadon mariné à l'oignon rouge
de Tropea

Pez espada escabechado con cebolla
roja de Tropea

500 g di pesce spada
Olio d'oliva
3 spicchi d'aglio
1 rametto di rosmarino
Buccia di un limone
400 g di cipolle rosse di Tropea
400 g di carote
50 g di farina
200 ml aceto di vino rosso
15 ml di miele
50 g di uva passa

Tagliare il pesce a pezzi di 4 cm di spessore.
Metterli in un recipiente e coprirli con olio, aglio,
rosmarino e la buccia di un limone affinché ne
acquistino il sapore. Lasciare marinare per alcu-
ne ore.

Cuocere il pesce al vapore a bassa temperatura
(60 °C). Dopo la cottura, lasciarlo in un reci-
piente ermetico avvolto in pellicola trasparente
per un'ora.
Pulire e tagliare le cipolle. Cuocerle in un tega-
me a fuoco lento finché diventano trasparenti e
perdono consistenza. Pulire e tagliare alla julien-
ne le carote, passarle nella farina e friggerle in
un tegame a fuoco vivo.
Impiattamento: In un piatto fondo mettere un
pezzo di pesce, disporvi sopra la cipolla e poi la
carota. Condire con olio, uva passa e aceto di
vino rosso ridotto e lasciato evaporare con un
po' di miele.

1 lb swordfish
Olive oil
3 garlic cloves
1 sprig of rosemary
Lemon skin
14 oz Tropea red onion
14 oz carrots
1 1/2 oz flour
200 ml red wine vinegar
15 ml honey
1 1/2 oz raisins

Cut the fish into about 1.5 in. thick pieces.
Place in a bowl and cover with oil, garlic, rose-
mary and lemon peel and leave to marinate for
a couple of hours.

Steam cook the fish at a low temperature
(140 °F). Once cooked place in sealable con-
tainer wrapped in cooking paper for an hour.
Clean and cut the onions. Cook them in a frying
pan on a low heat until soft and transparent.
Clean and cut the carrots in a julienne style,
powder with flour and fry in a pan on a high heat.
To serve: In a deep dish place the pieces of fish
and arrange the onions on top followed by the
carrots. Season with oil, reduced red wine vine-
gar with a little honey and raisins.

500 g Schwertfisch
Olivenöl
3 Knoblauchzehen
1 Bund Rosmarin
Schale einer Zitrone
400 g rote Zwiebeln
400 g Karotten
50 g Mehl
200 ml Rotweinessig
15 ml Honig
50 g Rosinen

Den Fisch in etwa 4 cm dicke Stücke schneiden. Die Stücke in eine Schale geben und in einer Mischung aus Öl, Knoblauch, Rosmarin und Zitronenschale einlegen. Einige Stunden ziehen lassen.

Den Fisch mit schwacher Hitze bei Dampf garen (60 °C). Den gegarten Fisch in Frischhaltefolie eingewickelt in einen hermetisch schließenden Behälter geben und eine Stunde ruhen lassen. Die Zwiebeln säubern und klein hacken. Auf kleiner Flamme in einer Pfanne anbraten, bis sie weich und glasig sind. Die Karotten säubern und in Streifen schneiden, in Mehl wälzen und bei starker Hitze in einer Pfanne anbraten. Serviervorschlag: Ein Stück Fisch in einen tiefen Teller geben und darüber zuerst die Zwiebeln und dann die Karotten setzen. Mit einer Sauce aus Öl, reduziertem und mit etwas Honig eingedampftem Rotweinessig und Rosinen anmachen.

500 g d'espadon
Huile d'olive
3 gousses d'ail
1 brin de romarin
Zeste d'un citron
400 g d'oignon rouge de Tropea
400 g de carottes
50 g de farine
200 ml de vinaigre de vin rouge
15 ml de miel
50 g de raisins secs

Couper le poisson en morceaux de 4 cm d'épaisseur. Les mettre dans un récipient et les couvrir d'huile, d'ail, de romarin et de zeste de citron para qu'ils puissent mariner. Laisser reposer quelques heures.

Cuire le poisson à la vapeur à petit feu (60 °C). La cuisson terminée, le placer, enveloppé d'un film transparent, dans un récipient hermétique pendant une heure. Nettoyer et trancher les oignons. Les faire revenir dans une poêle à feu doux jusqu'à ce qu'ils blondissent et deviennent transparents. Nettoyer et couper les carottes en julienne. Les saupoudrer de farine et les faire frire dans une poêle à feu vif. Service : Sur une assiette creuse, déposer un morceau de poisson. Le parer d'oignon puis de carottes. Arroser de vinaigre de vin rouge réduit et évaporé, accompagné de miel et de raisins secs.

500 g de pez espada
Aceite de oliva
3 dientes de ajo
1 ramita de romero
Piel de un limón
400 g de cebollas rojas de Tropea
400 g de zanahorias
50 g harina
200 ml vinagre de vino tinto
15 ml de miel
50 g de pasas

Trocear el pescado en piezas de unos 4 cm de grosor. Introducirlas en un recipiente y cubrirlas con aceite, ajo, romero y la piel de un limón para que queden adobadas. Dejar transcurrir unas horas.

Cocinar el pescado al vapor a baja temperatura (60 °C). Una vez cocido depositarlo en un recipiente hermético envuelto en papel transparente durante una hora. Limpiar y trocear las cebollas. Cocerlas en una sartén a fuego lento hasta que queden blandas y transparentes. Limpiar y cortar en juliana las zanahorias, pasarlas por harina y freírlas en una sartén a fuego vivo. Emplatado: En un plato hondo disponer una pieza de pescado y montarla primero con cebolla y después con zanahoria. Aliñar con aceite, vinagre de vino tinto reducido y evaporado con un poco de miel y unas pasas.

Emporio Armani Caffé

Design: Gabellini Associates, Giorgio Armani's
In House Architects | Chef: Luca Seveso

Via Croce Rossa 2 | 20121 Milan
Phone: +39 02 72318680
www.emporioarmani.com
Subway: Montenapoleone
Opening hours: Mon–Sat noon to 3 pm, 7:30 pm to 11 pm; bar, from 7 am to 1 am
Average price: € 50
Cuisine: Italian
Special features: Exclusively created menu (70% organic food); specialities: meat,
fish and home made pasta, cocktails with fingerfood

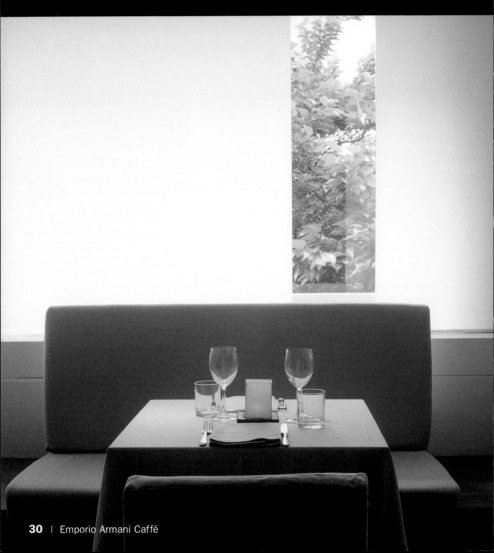

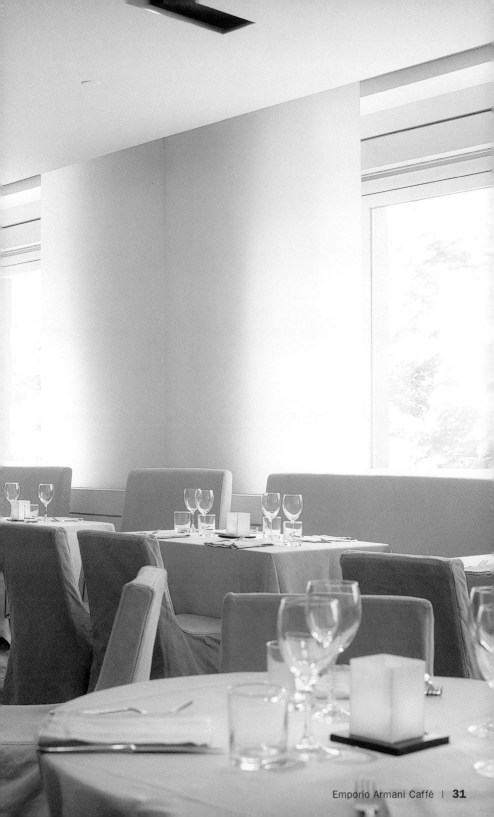

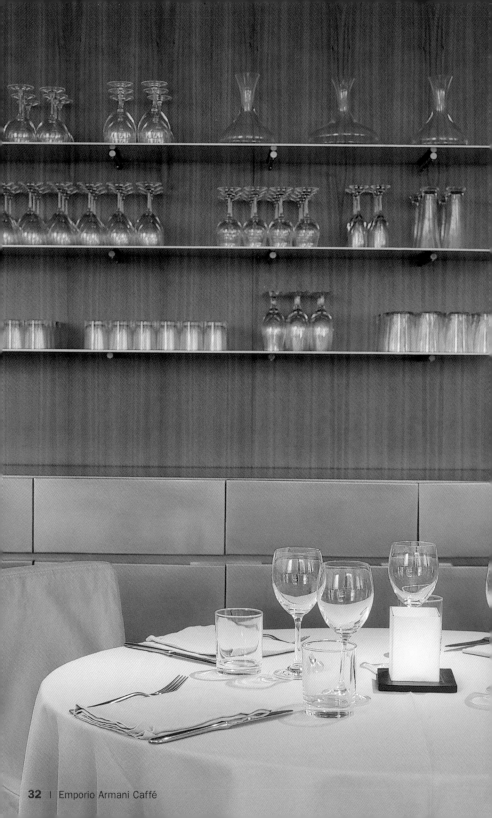

Rombo chiodato

con brodo di vongole e gamberoni

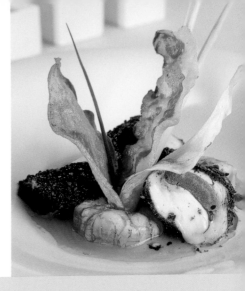

Turbot with Clam and King Prawn Stock

Steinbutt mit Sud aus Venusmuscheln und Garnelen

Turbot au bouillon de moules et langoustines

Rodaballo con caldo de almejas y langostinos

1 lombo di rombo chiodato da 400 g
200 g di mozzarella di bufala
100 ml di confettura di pomodori
Foglie di basilico
Olio d'oliva
Timo
Vongole
Gamberoni
1 ciuffo di erba cipollina
1 pomodoro maturo

Sfilettare il rombo in 4 pezzi. Praticare un'incisione nella parte centrale di ogni filetto per riempirlo con una foglia di basilico, 50 g di mozzarella e 25 ml di confettura di pomodoro. In un tegame scaldare l'olio e mettervi il timo, lasciare sul fuoco per pochi minuti evitando che l'olio inizi a bollire mantenerlo. Successivamente, cuocere i filetti a uno a uno nello stesso tegame.

In una casseruola, dorare l'erba cipollina sminuzzata e aggiungere il pomodoro maturo a tocchetti. Dopo alcuni minuti aggiungere i gamberoni interi e, poco dopo, le vongole precedentemente lavate con acqua salata per eliminare i resti della sabbia. Ridurre il tutto a 3/4. Separare le teste dei gamberoni dalle code; conservare queste ultime a parte insieme alle vongole. Passare al frullatore le teste insieme al brodo di frutti di mare e filtrare. Con una frusta amalgamare il brodo di frutti di mare, le code e le vongole messe da parte per ottenere una salsa omogenea.
Impiattamento: Disporre in un piatto un filetto di rombo e insaporirlo con la crema di frutti di mare tiepida. Decorare con le code di gamberoni passate sulla griglia.

1 turbot back (14 oz)
7 oz buffalo mozzarella
100 ml tomato confiture
Basil leaves
Olive oil
Thyme
Clams
King prawns
1 bunch of chives
1 mature tomato

Filet turbot into 4 portions. Make an insertion in the central part of each fillet to fill with basil leaves, 1 1/2 oz of mozzarella and 25 ml of tomato confiture. In a frying pan heat the oil and add thyme, leave for a couple of minutes without allowing the oil to boil. Next fry the fillets one by one in the pan.

In a casserole brown the sliced chives and mature tomato pieces. After a few minutes add the whole prawns, and a little after, the previously cleaned (with salted water to remove any remaining sand grains) clams. Reduce by 3/4. Separate the heads and tails of the prawns and set the tails aside with the clams. Grind the heads with the fish stock and strain. Use the blender to achieve a thick sauce with the fish stock, tails and set aside clams.
To serve: Arrange 1 turbot fillet on a dish and pour the lukewarm fish sauce over the turbot. Decorate with grilled 2 prawn tails.

1 Steinbuttfilet (400 g)
200 g Büffelmozzarella
100 ml Tomatenkonfitüre
Basilikumblätter
Olivenöl
Thymian
Venusmuscheln
Garnelen
1 Bund Schnittlauch
1 reife Tomate

Den Steinbutt in 4 Portionsstücke schneiden. Jedes Filet in der Mitte einschneiden und mit einem Blatt Basilikum, 50 g Mozzarella und 25 ml Tomatenkonfitüre füllen. In einer Pfanne Öl erhitzen und den Thymian dazugeben. Einige Minuten ziehen lassen, ohne dass das Öl den Siedepunkt erreicht. Anschließend die Filets in der Pfanne braten.

Das gehackte Schnittlauch in einer Pfanne bräunen und die in Würfel geschnittene reife Tomate dazugeben. Nach ein paar Minuten die ganzen Garnelen und kurz danach die Venusmuscheln dazugeben. Die Muscheln vorher mit Salzwasser waschen, um den restlichen Sand zu entfernen. Auf 3/4 reduzieren. Die Garnelenköpfe von den Schwänzen trennen und diese mit den Venusmuscheln zur Seite stellen. Die Köpfe zusammen mit dem Sud aus Meeresfrüchten pürieren und anschließend durch ein Sieb seihen. Mit einem Mixer eine gleichmäßige Sauce aus der Brühe und den beiseite gestellten Garnelen und Venusmuscheln herstellen.
Serviervorschlag: Auf einem Teller ein Steinbuttfilet anrichten und mit der lauwarmen Meeresfrüchtecreme bedecken. Mit zwei kurz angebratenen Garnelenschwänzen garnieren.

1 filet de turbot de 400 g
200 g de mozzarella de beauf
100 ml de tomate confite
Feuilles de basilic
Huile d'olive
Thym
Moules
Langoustines
1 bouquet ciboulette
1 tomate mure

Couper le turbot en 4 filets. Faire une incision au centre de chaque filet pour le farcir d'une feuille de basilic, de 50 g de mozzarella et de 25 ml de tomate confite. Dans une poêle, faire chauffer l'huile et y ajouter le thym. Maintenir la température quelques minutes sans que l'huile parvienne à ébullition. Ensuite, faire cuire les filets l'un après l'autre dans une poêle.

Dans une casserole, faire dorer la ciboulette émincée et y ajouter la tomate mure coupée en morceaux. Au bout de quelques minutes, ajouter les langoustines entiers et ensuite les moules bien nettoyées à l'eau salée pour qu'elle dégorge les restes de sable. Réduire au 3/4. Ôter les têtes des langoustines et réserver avec les moules. Passer les têtes au mixer avec le bouillon de fruits de mer et filtrer. Utiliser le fouet pour obtenir une sauce homogène avec le bouillon de fruits de mer, les queues de langoustines et les moules mises de côté.
Service : Disposer sur l'assiette 1 filet de turbot et l'arroser de la crème de fruits de mer encore tiède. Décorer avec deux queues de langoustines grillées.

1 lomo de rodaballo de 400 g
200 g de mozzarella de búfala
100 ml de tomate confitado
Hojas de albahaca
Aceite de oliva
Tomillo
Almejas
Langostinos
1 ramillete de cebollino
1 tomate maduro

Filetear el rodaballo en 4 porciones. Hacer una incisión en la parte central de cada filete para rellenarlo con una hoja de albahaca, 50 g de mozzarella y 25 ml de tomate confitado. En una sartén calentar aceite e introducir el tomillo, mantenerlo unos minutos sin dejar que el aceite llegue a hervir. Seguidamente cocinar los filetes uno a uno en esa sartén.

En una cazuela dorar el cebollino picado y añadir el tomate maduro troceado. Pasados unos minutos añadir los langostinos enteras y, poco después, las almejas previamente lavadas con agua salada para que escupan los restos de arena. Reducir 3/4 partes. Separar las cabezas de los langostinos de las colas y reservar éstas junto con las almejas. Pasar por la trituradora las cabezas junto al caldo de marisco y colar. Usar la batidora para conseguir una salsa homogénea con el caldo de marisco y las colas y las almejas reservadas.
Emplatado: Disponer en una plato 1 filete de rodaballo y salsearlo con la crema de marisco tibia. Decorar con dos colas de langostinos marcados a la plancha.

Galleria

Design: Mr. Papiri I Chef: Paola Budel

Hotel Principe di Savoia I Piazza della Repubblica 17 I 20214 Milan
Phone: +39 02 62302026
www.hotelprincipedisavoia.com
Subway: Repubblica
Opening hours: Mon–Sun 7 am to 11 am, 12:30 pm to 3 pm, 7 pm to 11 pm
Average price: € 50 – € 100 menu
Cuisine: Italian and regional creative cuisine
Special features: The salon is facing onto a flowering Italian garden, a charming niche where guests may also enjoy open-air dining in summer

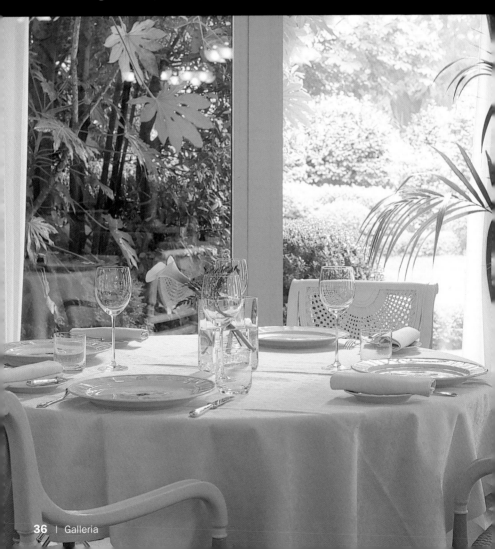

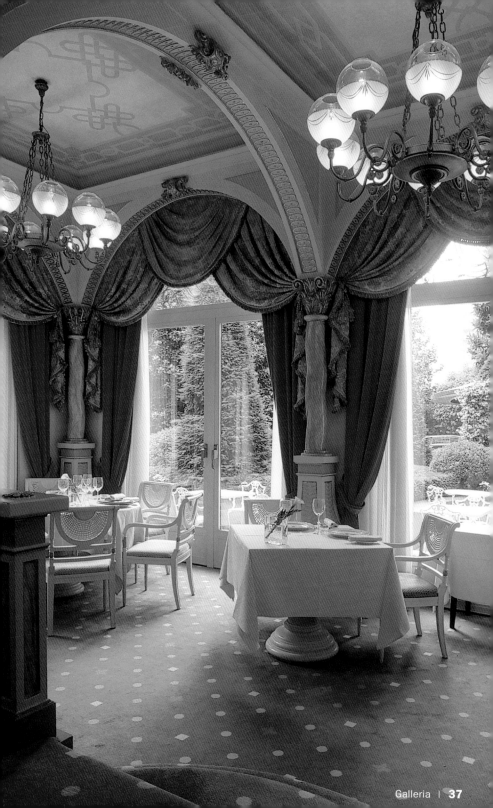

Gamberoni
con confettura di pesche e merluzzo

King Prawns with Peach Compote and Cod

Garnelen mit Pfirsichkompott und Stockfisch

Gros langoustines à la compote de pêche et morue

Langostinos con compota de melocotón y bacalao

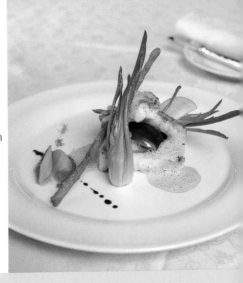

12 gamberoni freschi
8 fogli di pasta cotte
150 g di merluzzo fresco
100 g di confettura di pesche
1 pesca
Cuori di sedano
Salsa di gamberoni
Sale di Guérande e pepe
Miele
Aceto balsamico
Burro
Zucchero

Pulire e insaporire il merluzzo con il sale di Guérande, l'aglio e il pepe e cuocere al vapore per alcuni minuti. Dorare i gamberoni in poco olio.
Togliere la buccia alla pesca, tagliarla a pezzi piccoli e candirla con burro e zucchero.
Mescolare la salsa di gamberoni a un cucchiaio di miele.
Impiattamento: Per ogni porzione utilizzare 2 fogli di pasta e 50 g di merluzzo; disporvi sopra i gamberoni con due pezzi di pesca caramellata e coprire con la salsa di gamberoni. Decorare con i cuori di sedano e la confettura di pesca e condire con alcune gocce di aceto balsamico.

12 fresh king prawns
8 cooked lasagne pasta sheets
5 oz fresh cod
3 1/2 oz peach compote
1 peach
Celery hearts
King prawn sauce
Guérande salt and pepper
Honey
Balsamic vinegar
Butter
Sugar

Clean and season the cod with Guérande salt, garlic, and pepper and steam for a few minutes. Brown the king prawns with a little oil.
Peal and cut the peach into small pieces and mix with butter and sugar.
Beat the prawn sauce with a spoonful of honey.
To serve: For each ration use 2 sheets of pasta and 1 1/2 oz of cod; arrange on top of king prawns with two pieces of peach and cover with prawn sauce. Decorate with celery hearts and peach compote and season with a few drops of balsamic vinegar.

12 frische Garnelen
8 gekochte Nudelblätter
150 g frischen Stockfisch
100 g Pfirsichkompott
1 Pfirsich
Sellerieherzen
Garnelensauce
Guérande-Salz und Pfeffer
Honig
Balsamico-Essig
Butter
Zucker

Den Stockfisch säubern und mit Guérande-Salz, Knoblauch und Pfeffer würzen und einige Minuten mit Dampf garen. Die Garnelen mit etwas Öl goldbraun braten.
Den Pfirsich schälen und in kleine Stücke schneiden und in Butter und Zucker einlegen.
Die Garnelensauce mit einem Teelöffel Honig aufschlagen.
Serviervorschlag: Für jede Portion 2 Nudelblätter und 50 g Stockfisch nehmen. Auf die Garnelen legen, darüber zwei Stück Pfirsich mit Sirup legen und mit Garnelen-Sauce bedecken. Mit Sellerieherzen und Pfirsichkompott garnieren und mit etwas Balsamico-Essig würzen.

12 langoustines frais
8 tartelettes cuites
150 g de morue fraîche
100 g de compote de pêche
1 pêche
Cœurs de céleri
Sauce de langoustines
Sel de Guérande y poivre
Miel
Vinaigre balsamique
Beurre
Sucre

Nettoyer la morue et l'assaisonner de sel de Guérande, d'ail et de poivre. La faire cuire à la vapeur pendant quelques minutes. Faire dorer les langoustines dans un peu d'huile.
Peler et couper la pêche en petits morceaux et la faire confire dans du beurre et du sucre.
Fouetter la sauce de langoustines avec une cuillérée de miel.
Service : Pour chaque personne utiliser 2 tartelettes et 50 g de morue ; disposer deux langoustines au-dessus avec deux morceaux de pêche confite au sirop et napper de sauce de bouquet. Décorer avec les cœurs de céleris et la compote de pêches. Arroser de quelques gouttes de vinaigre balsamique.

12 langostinos frescos
8 láminas de pasta cocidas
150 g de bacalao fresco
100 g de compota de melocotón
1 melocotón
Corazones de apio
Salsa de langostinos
Sal de Guérande y pimienta
Miel
Vinagre balsámico
Mantequilla
Azúcar

Limpiar y sazonar el bacalao con sal de Guérande, ajo y pimienta y cocer al vapor durante unos minutos. Dorar los langostinos con un poco aceite.
Pelar y cortar el melocotón en trocos pequeños y almibararlo con mantequilla y azúcar.
Batir la salsa de langostinos con una cucharada de miel.
Emplatado: Para cada ración emplear 2 láminas de pasta y 50 g de bacalao; disponer encima los langostinos con dos trozos de melocotón almibarado y cubrir con la salsa de langostinos. Decorar con corazones de apio y compota de melocotón, y aliñar con unas gotas de vinagre balsámico.

Gioia 69

Design: Gianmaria Torno I Chef: Stefano Tonini

Via Melchiorre Gioia 69 I 20125 Milan
Phone: +39 02 66710180
www.milanorestaurants.it
Subway: Sondrio
Opening hours: Mon–Sat 8 pm to 11:30 pm
Average price: € 45 – € 55
Cuisine: Traditional Italian
Special features: Sicilian garden

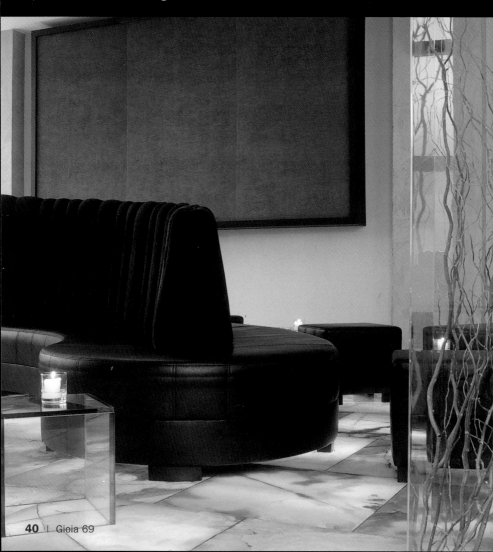

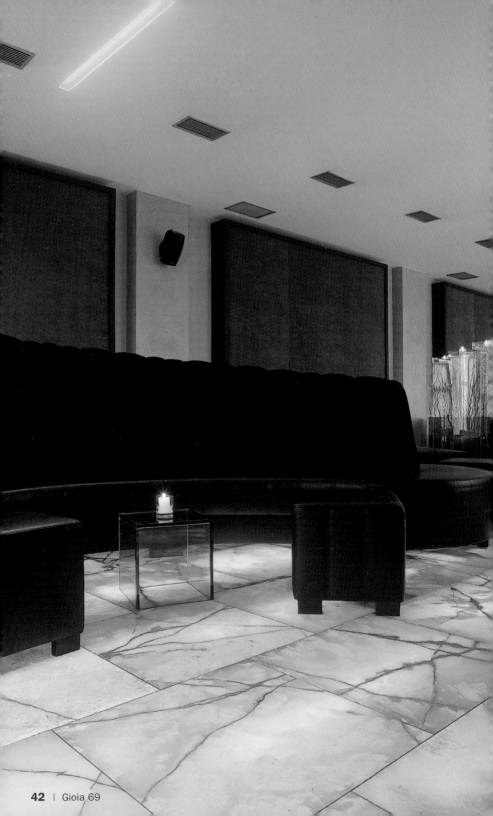

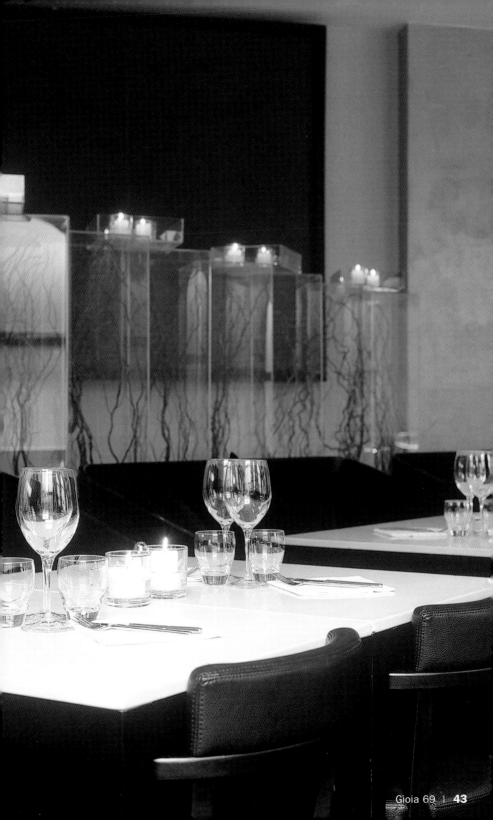

Fiori di zucchina

ripieni

Stuffed Courgettes Flowers
Gefüllte Zucchiniblüten
Fleurs de courgettes farcies
Flores de calabacín rellenas

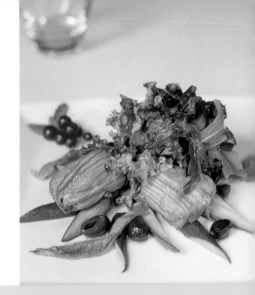

3 fiori di zucchina
30 g di lattuga
Ricotta fresca
20 g formaggio Montasio
1 melanzana
Olive taggiasche
Olio extravergine di oliva
Sale
Pepe nero
Mentuccia

Preparare il composto per il ripieno con la lattuga e il formaggio, aggiungere sale e pepe. Successivamente riempire i fiori dopo aver tolto il pistillo. Cuocere nel forno a vapore per 12 minuti coperto con carta da forno.
Grigliare la melanzana e conservare.
Impiattamento: Preparare in un piatto un letto di zucchine tiepide; disporre la melanzana al centro e distribuire intorno i fiori di zucchina tiepidi. Accompagnare con olive taggiasche e decorare con foglie di lattuga. Servire a temperatura ambiente con un filo d'olio, del formaggio Montasio e foglie di basilico.

3 courgettes flowers
1 oz lettuce
Fresh ricotta
3/4 oz Montasio cheese
1 aubergine
Taggiasche olives
Extra virgin olive oil
Salt
Black pepper
Poleo

Prepare the compound for the filler with the lettuce and cheese sprinkled with salt and pepper. Then fill the courgette flowers, once the pistil is removed. Steam cook for about 12 minutes while covered with aluminium foil.
Grill the aubergine and put to one side.
To serve: Prepare a bed of courgette slices on a plate, and arrange the aubergine in the centre and surround with lukewarm courgette flowers. Accompany with taggiasche olives and top with lettuce leaves. Serve at a moderate temperature with a sprinkling of oil and small chunks of Montasio cheese and basil leaves.

3 Zucchiniblüten
30 g Salat
Frischer Ricotta
20 g Montasio-Käse
1 Aubergine
Taggiasche-Oliven
Natives Olivenöl Extra
Salz
Schwarzer Pfeffer
Minze

Die Füllung aus Salat und Käse herstellen und mit Salz und Pfeffer abschmecken. Den Stempel aus den Blüten entfernen und diese füllen. Im Ofen etwa 12 Minuten mit Backpapier zugedeckt bei Dampf garen. Die Auberginen natur anbraten und zur Seite stellen.
Serviervorschlag: Auf einem Teller ein Bett aus Zucchini vorbereiten. Die Aubergine in der Mitte verteilen und mit den noch warmen Zucchiniblüten einrahmen. Mit den Taggiasche-Oliven und Salat garnieren. Lauwarm mit einem Schuss Öl und etwas Montasio-Käse und Basilikumblättern servieren.

3 fleurs de courgette
30 g de laitue
Ricotta fraîche
20 g de fromage Montasio
1 aubergine
Olives « taggiasche »
Huile d'olive extra vierge
Sel
Poivre noir
Pouliot (menthe forte)

Préparer la farce avec la laitue et le fromage assaisonné de sel et poivre. Retirer le pistil des fleurs et les farcir. Cuire au four, recouvertes d'un papier sulfurisé et à la vapeur pendant 12 minutes.
Griller l'aubergine et mettre de côté.
Service : Déposer sur une assiette un fond fait de lamelles de courgettes; disposer l'aubergine au centre et décorer tout autour de fleurs de courgettes encore tièdes. Accompagner d'olives « taggiasche » et couronner de feuilles de laitue. Servir tiède avec un filet d'huile, agrémenté de quelques morceaux de fromage Montasio et de feuilles de basilic.

3 flores de calabacín
30 g de lechuga
Ricotta fresca
20 g queso Montasio
1 berenjena
Aceitunas taggiasche
Aceite de oliva extravirgen
Sal
Pimienta negra
Poleo

Preparar el compuesto para el relleno con la lechuga y el queso salpimentados. Luego rellenar las flores, una vez desechado el pistilo. Cocer al horno a vapor durante unos 12 minutos cubiertas con papel de horno.
Cocinar la berenjena a la plancha y reservar.
Emplatado: Preparar en un plato un lecho tiras de calabacín; disponer la berenjena en el centro y rodearla con las flores de calabacín todavía tibias. Acompañar con aceitunas taggiasche y coronar con hojas de lechuga. Servir a temperatura tibia con un chorrito de aceite y una picada de queso Montasio y hojas de albahaca.

Just Cavalli Café

Design: Italo Rota | Chef: Tiziano Marabisso

Viale Camoens c/o Torre Branca | 20121 Milano
Phone: +39 02 311817
www.justcavallicafe.com
Subway: Cadorna
Opening hours: Mon–Sun 6.30 pm to 2 am; lunch, from 12:30 pm to 5 pm
Average price: € 70
Cuisine: Italian cuisine and sushi
Special features: Outdoor garden, happy hour from 7 pm to 9 pm

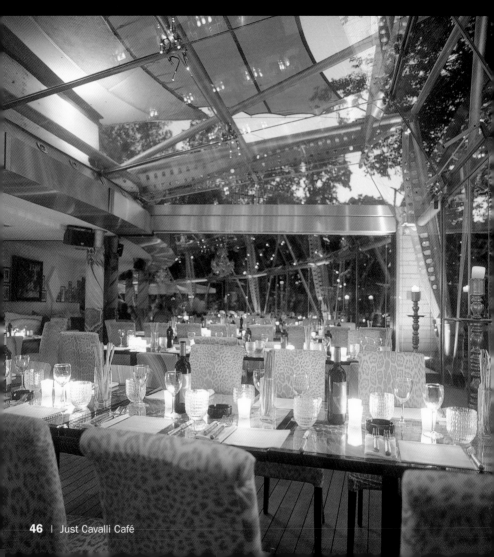

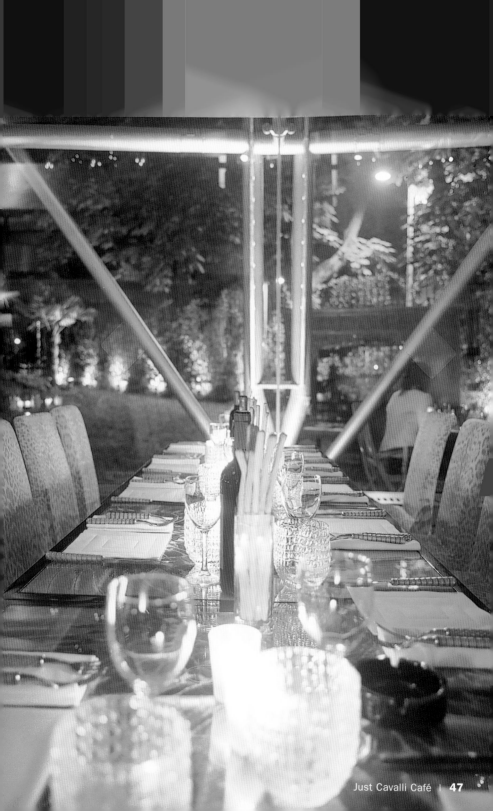

Insalata

di melanzane agrodolci

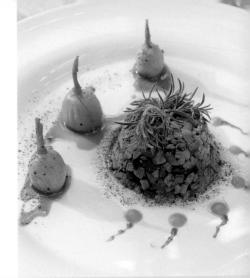

Sweet and Sour Aubergine Salad

Süß-saurer Auberginensalat

Salade d'aubergines aigres-douces

Ensalada de berenjenas agridulces

2 melanzane
6 ravanelli
Olio d'oliva
Aceto bianco
Zucchero glassato
Sale
Pepe nero
Rosmarino

Pulire e spellare le melanzane. Tagliarle a dadini e friggerle in olio d'oliva a 180 °C. Scolarle e lasciare riposare per 15 minuti. In una terrina preparare una vinaigrette con l'aceto bianco, lo zucchero glassato, il sale e il pepe. Condire le melanzane con la vinaigrette e mettere il composto ottenuto in stampi da crème caramel. Conservare.

Pulire i ravanelli. In un tegame, versare in parti uguali aceto bianco e acqua e immergervi i ravanelli interi, lasciandoli cuocere finché il liquido evapora completamente. Aggiungere sale, pepe e zucchero.

Impiattamento: Togliere le melanzane dallo stampo in un piatto e disporvi accanto tre ravanelli. Condire con il resto della vinaigrette e decorare con un rametto di rosmarino.

2 aubergines
6 radishes
Olive oil
White vinegar
Icing sugar
Salt
Black pepper
Rosemary

Clean and peal the aubergines. Dice into small pieces and fry in olive oil at about 350 °F. Drain and set aside for 15 minutes. In a bowl prepare the vinaigrette with white vinegar, icing sugar, salt and pepper. Season the aubergines with the vinaigrette and arrange in flan mould. Set aside. Clean the radishes of impurities. In a pan, pour in equal measures white vinegar and water and add the radishes whole. Cook until the liquid has evaporated completely. Add salt, pepper, and icing sugar. Set aside.

To serve: Remove one of the aubergine compounds from its mould on a plate and arrange three radishes around it. Season with the remaining vinaigrette and decorate with a sprig of rosemary.

2 Auberginen
6 Rettiche
Olivenöl
Weißweinessig
Puderzucker
Salz
Schwarzer Pfeffer
Rosmarin

Die Auberginen säubern und schälen. In kleine Würfel schneiden und in Olivenöl bei 180 °C frittieren. In einem Sieb abtropfen lassen und 15 Minuten ruhen lassen. In einer Schale eine Vinaigrette aus Weißweinessig, Puderzucker, Salz und Pfeffer zubereiten. Die Auberginen mit der Vinaigrette würzen und die so erhaltene Mischung in kleine Puddingformen füllen. Zur Seite stellen.
Die Rettiche reinigen. Weißweinessig und Wasser zu gleichen Teilen sowie die ganzen Rettiche in die Pfanne geben. Kochen lassen, bis die Flüssigkeit vollständig verdampft ist. Mit Salz, Pfeffer und Puderzucker abschmecken. Zur Seite stellen.
Serviervorschlag: Je eine Puddingform mit der Auberginenmischung auf einen Teller stürzen und drei Rettiche herum anordnen. Mit der restlichen Vinaigrette anmachen und einem Zweig Rosmarin garnieren.

2 aubergines
6 radis
Huile d'olive
Vinaigre de vin blanc
Sucre glace
Sel
Poivre noir
Romarin

Nettoyer et éplucher les aubergines. Les couper en petits dés et les faire frire dans de l'huile d'olive, à 180 °C. Les égoutter et les laisser reposer pendant 15 minutes. Dans un bol, préparer une vinaigrette avec le vin blanc, le sucre glace, le sel et le poivre. Assaisonner les aubergines avec cette vinaigrette. Déposer la préparation obtenue dans des petits moules à soufflé.
Nettoyer les radis. Dans une poêle, mettre du vinaigre de vin blanc et de l'eau en quantités égales. Y déposer les radis entiers. Les faire cuire jusqu'à évaporation complète du liquide. Ajouter le sel, le poivre et le sucre glace. Réserver.
Service : Démouler un des flancs d'aubergines sur une assiette et déposer tout autour trois radis. Arroser avec le reste de vinaigrette et décorer d'un brin de romarin.

2 berenjenas
6 rábanos
Aceite de oliva
Vinagre blanco
Azúcar glasé
Sal
Pimienta negra
Romero

Limpiar y pelar las berenjenas. Cortarlas en dados pequeños y freírlas en aceite de oliva a 180 °C. Pasarlas a un escurridor y dejarlas reposar durante 15 minutos. En un bol preparar una vinagreta con el vinagre blanco, el azúcar glasé, sal y pimienta. Condimentar la berenjena con la vinagreta y disponer la mezcla obtenida en moldes de flan. Reservar.
Limpiar de impurezas los rábanos. En una sartén, disponer dos partes iguales de vinagre blanco y agua e introducir los rábanos enteros. Cocerlos hasta que se hayan evaporado completamente los líquidos. Añadir sal, pimienta y azúcar glasé. Retirar.
Emplatado: Desmoldar uno de los flanes de berenjenas en un plato y disponer a su alrededor tres rábanos. Aliñar con el sobrante de la vinagreta y decorar con una ramita de romero.

Kisho

Design: Romeo Sozzi | Executive chef: Kazuteru Yonemura

Via Morosini 12 | 20135 Milan
Phone: +39 02 55010058
Subway: Porta Romana
Opening hours: Mon 2:30 pm to 11 pm, Tue–Sat 12:30 pm to 3 pm, 7:30 pm
to 11 pm
Average price: € 30 – € 70
Cuisine: Typical & creative Japanese
Special features: Executive

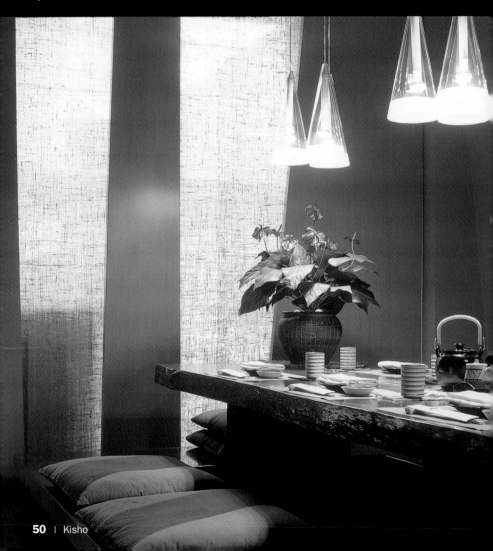

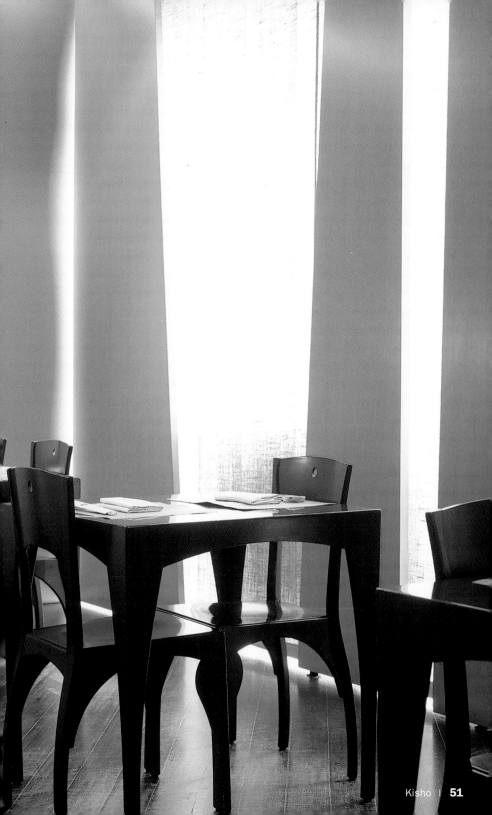

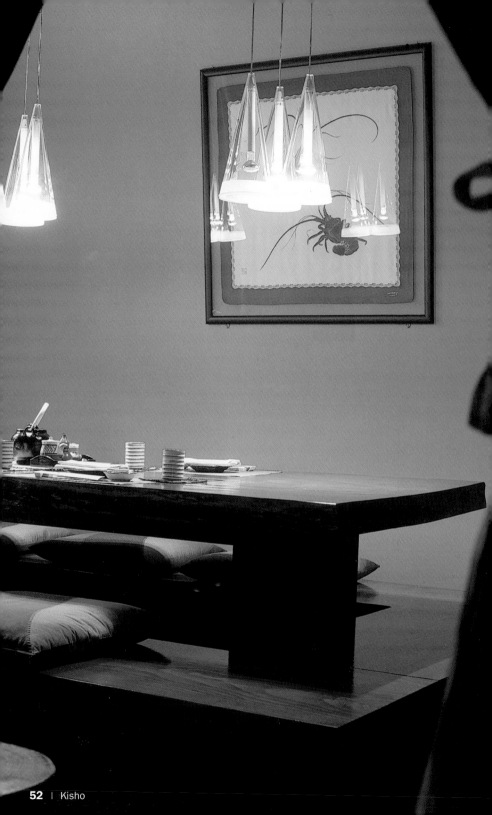

Stick Samurai

Samurai Stick

Samurai-Stangen

Stick Samurai

Stick Samurai

50 g di bambú
100 g di pesce bianco fresco
50 g di gamberetti
1 uovo
2 fogli di pasta di riso
30 g di maionese
20 g di vermicelli di riso cotti
Salsa piccante
Olio
Prezzemolo

Separare le code dei gamberetti dalle teste e sgusciarle. Sbattere l'uovo, impanare i gambe- retti e friggerli in un tegame con olio molto caldo. In una terrina disporre il pesce bianco crudo e i gamberetti fritti, aggiungere la maio- nese e mescolare bene fino ad ottenere un impasto compatto.
Stendere i fogli di pasta di riso e coprirli con uno strato sottile del ripieno ottenuto. Arrotolare il tutto e friggere velocemente in un tegame con olio molto caldo.
Impiattamento: Tagliare il bambú in pezzi di circa 20 cm di lunghezza e metterlo in un reci- piente insieme a due rotoli di pesce. Disporlo in un piatto sopra un letto di prezzemolo e vermi- celli di riso e accompagnare con salsa piccante.

1 1/2 oz bamboo
3 1/2 oz fresh white fish
1 1/2 oz prawns
1 egg
2 sheets of rice pasta
1 oz mayonnaise
3/4 oz cooked rice noodles
Spicy sauce
Oil
Parsley

Separate the prawns' tails and heads and peal the rest. Whisk an egg and dip the tails in bat- ter and cook in a frying pan with very hot oil. Place the raw fish and prawns in batter in a bowl and add the mayonnaise and mix until a thick paste is achieved.
Layout the sheets of rice pasta and apply a fine covering of the paste. Roll to create the shape of a stick. Lightly fry in a pan with very hot oil. To serve: Cut the bamboo in pieces of about 8 in. long and place in pot like container togeth- er with two fish sticks. Arrange on a plate on a bed of parsley and rice noodles and accompany with spicy sauce.

50 g Bambus
100 g frischen weißen Fisch
50 g Krevetten
1 Ei
2 Blätter Reisnudeln
30 g Mayonnaise
20 g gekochte Reisnudeln
Scharfe Sauce
Öl
Petersilie

Die Hinterteile der Krevetten von den Köpfen trennen und schälen. Das Ei schlagen, die Krevetten darin eintauchen und dann mit sehr heißem Öl in einer Pfanne anbraten. Den rohen weißen Fisch und die angebratenen Krevetten in eine Schale geben, die Mayonnaise dazugeben und zu einem zähflüssigen Brei verrühren. Die Reisnudelblätter auslegen und mit einer dünnen Schicht des Breis bestreichen. Zu kleinen Stangen einrollen. Mit sehr heißem Öl kurz in einer Pfanne frittieren.
Serviervorschlag: Den Bambus in etwa 20 cm lange Stücke schneiden und mit je zwei Fischstangen in Servierschalen mit hohem Rand setzen. Die Schalen auf einen Teller auf ein Bett aus Petersilie und Reisnudeln setzen. Mit scharfer Sauce servieren.

50 g de bambou
100 g de poisson blanc frais
50 g de crevettes
1 œuf
2 feuilles de riz
30 g de mayonnaise
20 g de vermicelle de riz cuites
Sauce piquante
Huile
Cerfeuil

Ôter les têtes des crevettes garder les queues et les éplucher. Fouetter l'œuf, enrober et faire frire les queues dans une poêle contenant de l'huile très chaude. Prendre un bol et y déposer le poisson blanc cru et les crevettes sautées. Ajouter la mayonnaise et bien mélanger jusqu'à obtention d'une pâte compacte. Etendre les feuilles de riz et les couvrir d'une fine couche de la farce obtenue. Les rouler pour obtenir un bâtonnet. Faire frire dans une poêle contenant de l'huile très chaude.
Service : Couper le bambou en morceaux de 20 cm de long et les déposer dans un récipient en terre cuite à côté de deux bâtonnets de poisson. Sur une assiette, faire un lit de persil et de vermicelles de riz et y déposer les bâtonnets. Agrémenter d'une sauce piquante.

50 g de bambú
100 g de pescado blanco fresco
50 g de gambas
1 huevo
2 láminas de pasta de arroz
30 g de mayonesa
20 g de fideos de arroz cocidos
Salsa picante
Aceite
Perejil

Separar las colas de gamba de las cabezas y pelarlas. Batir el huevo, rebozar las colas y freírlas en una sartén con aceite muy caliente. En un bol disponer el pescado blanco crudo y las gambas rebozadas, añadir la mayonesa y mezclar bien hasta conseguir una pasta compacta. Extender las láminas de pasta de arroz y cubrirlas con una fina capa del relleno obtenido. Enrollar para conseguir que tengan forma de palo. Freír ligeramente en una sartén con aceite muy caliente.
Emplatado: Cortar el bambú en trozos de unos 20 cm de longitud y depositarlos en un recipiente tipo vasija junto a dos palos de pescado. Disponerlo en un plato sobre un lecho de perejil y fideos de arroz y acompañar de salsa picante.

La Banque

Design: Daniele Berettia I Chef: Alessandro Boerchi

Via Bassano Porrone 6 I 20121 Milan
Phone: +39 02 86996565
www.labanque.it
Subway: Cordusio
Opening hours: Lounge bar, 6 pm to 9 pm; restaurant, 8 pm to 11 pm; disco,
from 11 pm
Average price: € 45
Cuisine: Italian
Special features: Happy hour and lounge bar, from 6 pm to 9 pm

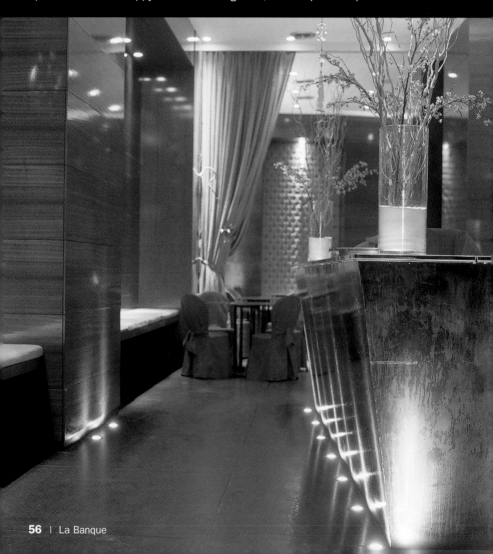

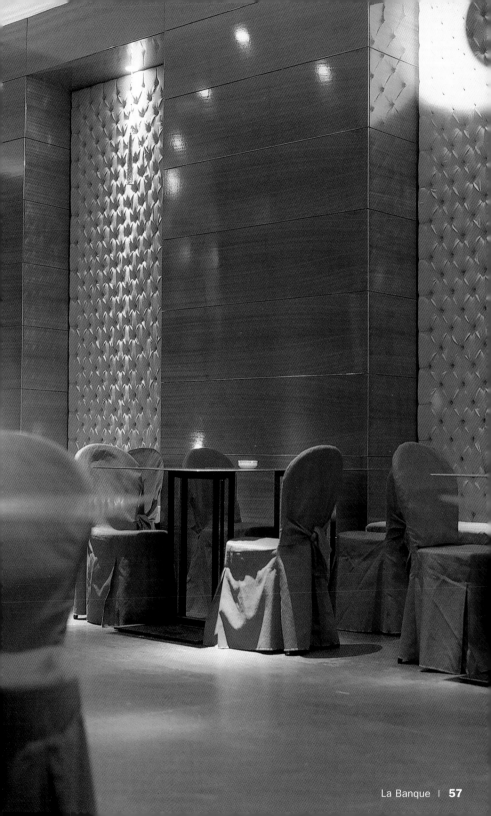

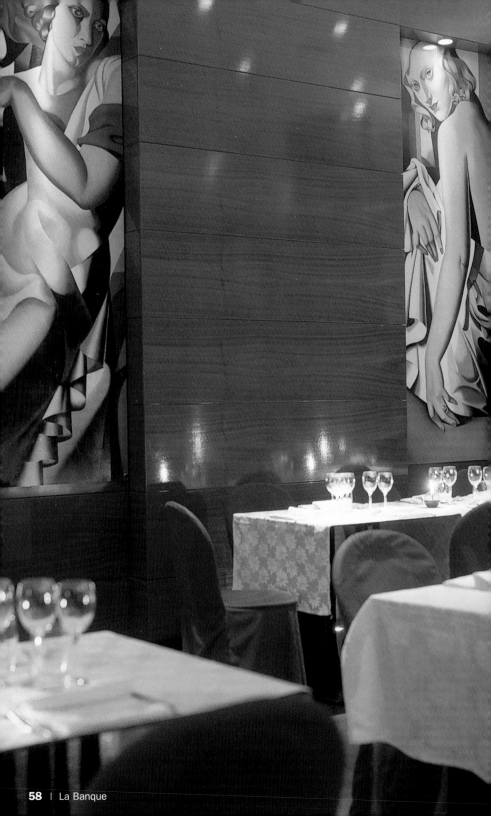

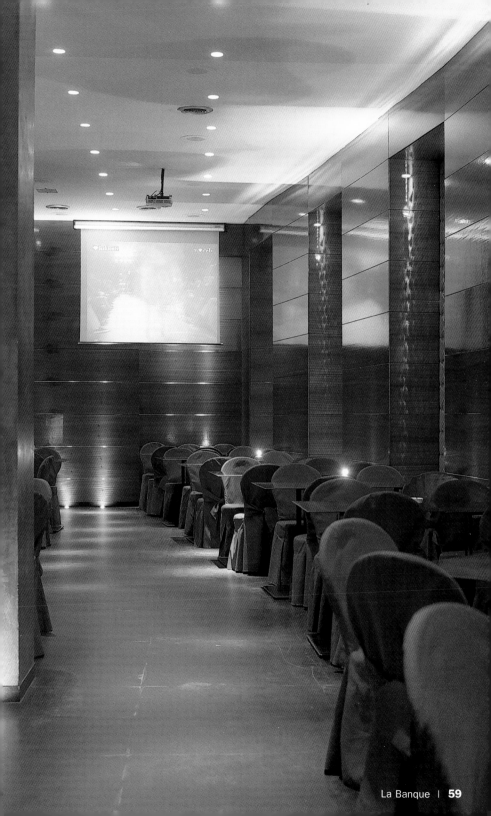

Tagliatelle
con aragoste e branzino

Noodles with Lobster and Seabass
Bandnudeln mit Langusten und Wolfsbarsch
Nouilles à la langouste et au bar
Tallarines con langosta y lubina

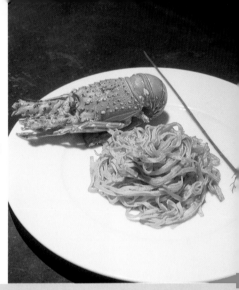

500 g di polpa di branzino
6 aragoste
200 g di polpa di pomodoro
500 g di tagliatelle
Pomodori secchi
3 scalogni
1 spicchio d'aglio piccolo
250 ml di vino bianco
Sale e pepe
40 ml di olio extravergine d'oliva

Sminuzzare gli scalogni e lo spicchio d'aglio e soffriggere in olio. Aggiungere la polpa di branzino e le aragoste spezzatatte. Bagnare con vino bianco e lasciare che perdano consistenza. Aggiungere la polpa di pomodoro con i pomodori secchi sminuzzati. Salare e pepare.
Cuocere per circa 20 minuti. Filtrare per ottenere un brodo.
Cuocere la pasta in abbondante acqua salata. Scolarla al dente. Condire con il brodo di pesce e servìre.

1 lb of sea bass meat
6 lobsters
7 oz of tomato pulp
1 lb noodles
Dried tomatoes
3 shallots
1 small clove of garlic
250 ml white wine
Salt and pepper
40 ml of extra virgin olive oil

Chop the shallots and garlic clove and lightly fry in oil. Add the sea bass meat and chopped lobsters. Bathe in white wine and leave so it becomes tender. Add the tomato pulp and flaked dried tomatoes. Add pepper and salt.
Cook for 20 minutes. Strain to obtain a sauce.
Boil the pasta in plenty of salted water. Strain when al dente. Season with the fish sauce and serve.

500 g Wolfsbarsch
6 Langusten
200 g Tomatenfleisch
500 g Bandnudeln
Getrocknete Tomaten
3 Schalotten
1 kleine Knoblauchzehe
250 ml Weißwein
Salz und Pfeffer
40 ml Olivenöl extra

Die Schalotten und die Knoblauchzehe würfeln und in Öl anbraten. Den Wolfsbarsch und die geschnittenen Langusten dazugeben. Mit Weißwein bedecken und garen lassen. Das Tomatenfleisch zusammen mit den entkernten getrockneten Tomaten dazu geben. Mit Salz und Pfeffer abschmecken.
20 Minuten kochen lassen. Durch ein Sieb geben, um eine Brühe zu erhalten.
Die Nudeln in reichlich Wasser mit Salz kochen. Abgießen, so dass die Nudeln al dente sind. Mit der Fischbrühe würzen und servieren.

500 g de chair de bar
6 langoustes
200 g de pulpe de tomate
500 g de nouilles
Tomates séchées
3 échalotes
1 petite gousse d'ail
250 ml de vin blanc
Sel et poivre
40 ml d'huile d'olive extra-vierge

Emincer l'échalote et les gousses d'ail et les faire blondir dans de l'huile. Y ajouter la chair de bar et les langoustes tranchée. Ajouter le vin blanc et les laisser cuire. Ajouter la pulpe de tomate ainsi que les tomates séchées hachées menu. Saler et poivrer.
Faire cuire pendant 20 minutes. Filtrer pour obtenir un court-bouillon.
Faire bouillir l'eau avec du sel et y ajouter les pâtes. Les jeter dans la passoire lorsqu'elles sont « al dente ». Les assaisonner avec le court-bouillon et servir.

500 g de carne de lubina
6 langostas
200 g de pulpa de tomate
500 g de tallarines
Tomate secos
3 chalotes
1 diente de ajo pequeño
250 ml de vino blanco
Sal y pimienta
40 ml aceite de oliva extra

Trocear los chalotes y el diente de ajo y sofreír en aceite. Añadir la carne de lubina y las langostas troceadas. Bañar con vino blanco y dejar que se ablande. Añadir la pulpa de tomate junto con tomates secos desmenuzados. Salpimentar.
Cocer durante unos 20 minutos. Colar para obtener un caldo.
Hervir la pasta en abundante agua con sal. Colarla al dente. Salsear con el caldo de pescado y servir.

Four Seasons Hotel | Via Gesù 6-8 | 20121 Milan
Phone: +39 02 77088
www.fourseasons.com
Subway: San Babila, Montenapoleone
Opening hours: Mon–Sun 7 am to midnight
Average price: € 50 – € 70
Cuisine: Mediterranean
Special features: Vegetarian menu available, parts of the menu change daily

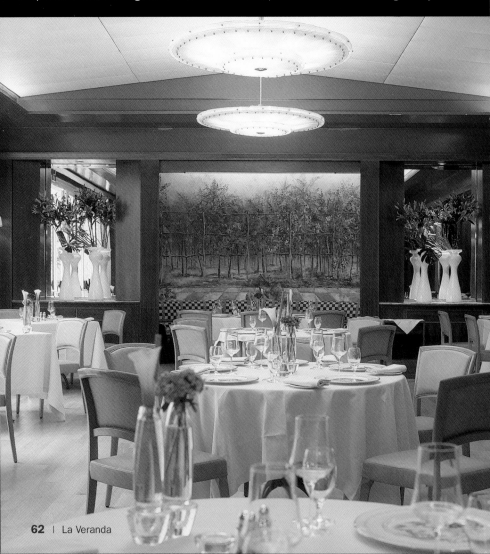

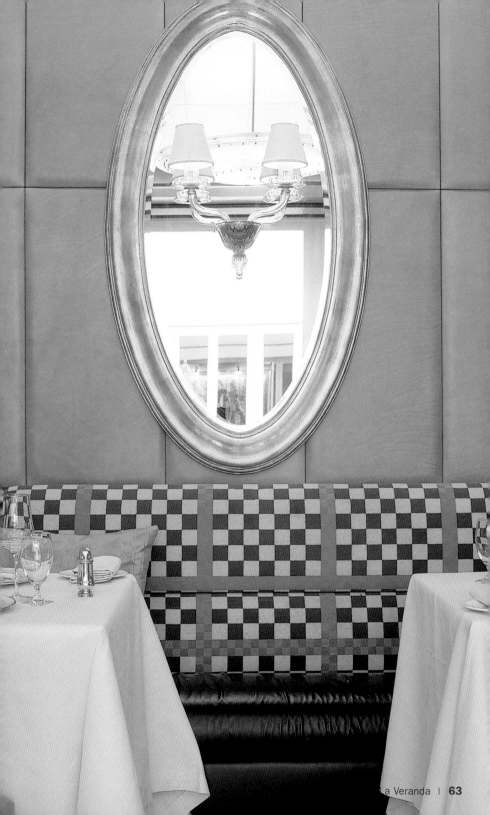

Medaglioni di vitello

con timo e asparagi alla parmigiana

Veal Medallions with Thyme
and Asparagus Parma Style

Kalbsmedaillons mit Thymian
und Spargel nach Parma-Art

Médaillons de veau au thym
et asperges à la mode parmesane

Medallones de ternera con tomillo
y espárragos al estilo parmesano

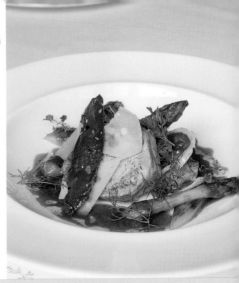

Medaglioni: 130 g di medaglioni di vitello, 2 g di timo, 1 spicchio d'aglio, 20 g di burro, 20 g di brodo, 20 g di vino bianco Traminer, 10 ml di olio d'oliva, sale e pepe.

Insaporire la carne con timo, aglio, sale e pepe e cuocere in una casseruola con burro e aglio. Togliere la carne dalla casseruola e stemperare la salsa restante aggiungendo il vino e il brodo. Mantenere caldi i medaglioni.

Asparagi: 200 g di asparagi verdi, 20 g di burro, 20 g di scalogno, erbe aromatiche, cerfoglio, maggiorana, salvia.

Pulire e lavare gli asparagi; sbollentarli in acqua e sale (7 g di sale per ogni litro d'acqua) e lasciar raffreddare in acqua e ghiaccio. Saltarli in un tegame con burro, scalogno, erbe aromatiche e salvia. Mantenere caldo.

Impiattamento: Servire due medaglioni in mezzo al piatto coperti con la salsa. Accompagnare con gli asparagi, il timo, alcune scaglie di parmigiano e jamón ibérico.

Medallions: 4 1/2 oz veal medallions, 1/2 tsp thyme, 1 garlic clove, 3/4 oz butter, 3/4 oz stock, 3/4 oz of traminer white wine, 10 ml of olive oil, salt and pepper.

Season the meat with thyme, garlic, salt and pepper and stew in a casserole with butter and garlic. Remove the meat from the casserole and deglaze by adding wine and stock to the remaining sauce. Keep the medallions hot.

Asparagus: 7 oz green asparagus, 3/4 oz butter, 3/4 oz shallots, aromatic herbs, chervil, marjoram, sage.

Clean the asparagus; whiten in boiling salted water (1 1/2 tsp of salt for every litre) and allow to cool in iced water. Sauté in a frying pan with butter, shallots, aromatic herbs and sage. Keep hot.
To serve: Place the two medallions in the centre of the plate with the deglazed sauce on top accompanied by the asparagus, thyme and some parmesan chunks and Iberian ham.

Medaillons: 130 g Kalbsmedaillons, 2 g Thymian, 1 Knoblauchzehe, 20 g Butter, 20 g Brühe, 20 g Traminer, 10 ml Olivenöl, Salz und Pfeffer.

Das Fleisch mit Thymian, Knoblauch, Salz und Pfeffer würzen und in einem Schmortopf mit Butter und Knoblauch anbraten. Das Fleisch aus dem Topf nehmen und den Wein und die Brühe zur verbleibenden Sauce dazugeben und deglasieren. Die Medaillons warm stellen.

Spargel: 200 g grüner Spargel, 20 g Butter, 20 g Schalotten, feine Kräuter, Kerbel, Majoran, Salbei.

Spargel säubern und waschen. In Salzwasser kochen (7 g pro Liter Wasser) und in Eiswasser abkühlen lassen. In einer Pfanne mit Butter, den Schalotten, feinen Kräutern und Salbei anbraten. Warm stellen.

Serviervorschlag: Die beiden Medaillons in die Mitte des Tellers legen und mit dem Bratenfond übergießen. Als Beilage Spargel, frischen Thymian, einige Stückchen Parmesankäse und iberischen Schinken servieren.

Médaillons : 130 g de médaillons de veau, 2 g de thym, 1 gousse d'ail, 20 g de beurre, 20 g de bouillon, 20 g de vin blanc Traminer, 10 ml d'huile d'olive, sel et poivre.

Assaisonner la viande de thym, d'ail, de sel et poivre et faire rôtir dans la casserole avec le beurre et l'ail. Retirer la viande de la casserole et déglacer en ajoutant le vin et le bouillon à la sauce restante. Réserver les médaillons au chaud.

Asperges : 200 g d'asperges vertes, 20 g de beurre, 20 g d'échalote, herbes aromatiques, cerfeuil, marjolaine, sauge.

Eplucher et laver les asperges. Les blanchir dans de l'eau bouillante (7 g de sel pour un litre d'eau) et laisser refroidir avec de la glace. Les faire revenir dans une poêle avec du beurre, de l'échalote, des herbes aromatiques et de la sauge. Garder au chaud.

Service : Servir deux médaillons au centre de l'assiette et napper de sauce déglacée. Agrémenter d'asperges. Parsemer de thym frais et de quelques dés de parmesan et de jambon ibérico.

Medallones: 130 g de medallones de ternera, 2 g de tomillo, 1 diente de ajo, 20 g de mantequilla, 20 g de caldo, 20 g de vino blanco Traminer, 10 ml de aceite de oliva, sal y pimienta.

Condimentar la carne con tomillo, ajo, sal y pimienta y guisar en la cazuela con mantequilla y ajo. Retirar la carne de la cazuela y desglasar añadiendo el vino y el caldo a la salsa restante. Mantener los medallones en caliente.

Espárragos: 200 g de espárragos verdes, 20 g de mantequilla, 20 g de chalote, hierbas aromáticas, perifollo, mejorana, salvia.

Limpiar y lavar los espárragos; blanquearlos en agua con sal hirviendo (7 g de sal por cada litro de agua) y dejar enfriar en agua con hielo. Saltearlos en una sartén con mantequilla, chalote, hierbas aromáticas y salvia. Mantener caliente.

Emplatado: Servir dos medallones en medio del plato y cubrir con la salsa desglasada. Acompañar con los espárragos, tomillo fresco, unos tacos de parmesano y jamón ibérico.

Le Noir

Design: Guido Ciompi I Chef: Luciano Sarzi Sartori

Hotel The Gray I Via San Raffaele 6 I 20121 Milan
Phone: +39 02 7208951
www.sinahotels.com
Subway: Duomo
Opening hours: Mon–Sun 12:30 pm to 2:30 pm and 7:30 pm to 10:30 pm
Average price: € 65
Cuisine: Innovative Italian
Special features: Le Noir restaurant, a black box to lounge inside, with rollaway
tables on rails

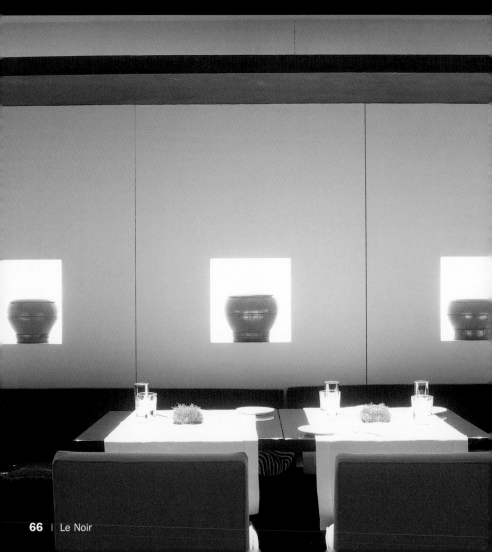

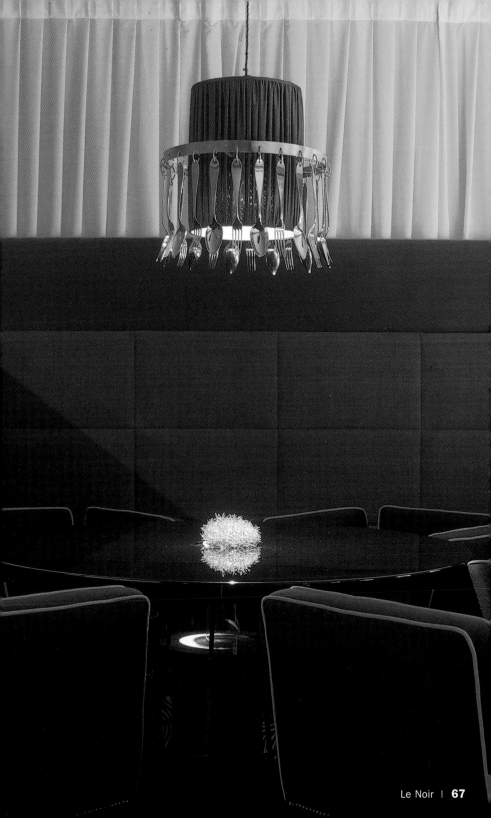

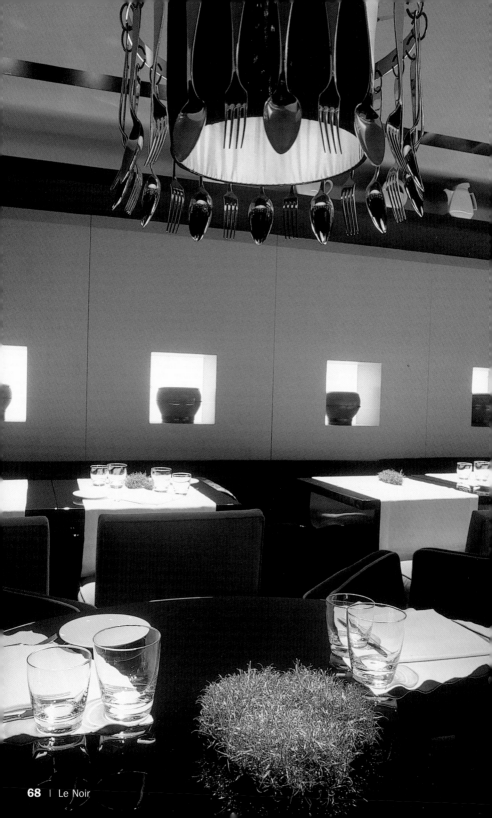

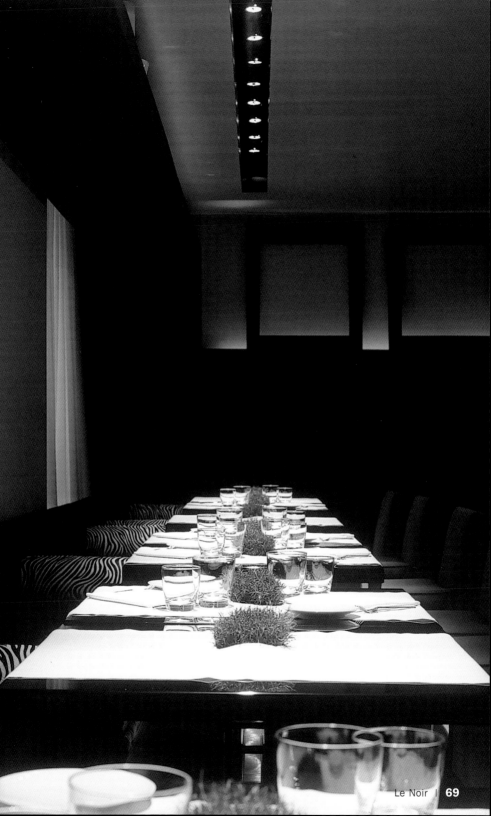

Code di gamberoni

con mango

King Prawn tails with Mango

Garnelenschwänze mit Mango

Queues de langoustines à la mangue

Colas de langostinos con mango

3 gamberoni
1 rametto di aneto
3 fili di erba cipollina
1 pomodoro secco
1 cucchiaio di olio d'oliva extravergine
3 gocce di aceto balsamico di Modena
100 g di mango

Sgusciare i gamberoni, dividere le teste dalle code e cuocere il tutto al vapore per due minuti. Tagliare il mango a fette e conservare.
In un ciotola mescolare energicamente l'aceto balsamico, l'olio d'oliva e l'erba cipollina fino ad ottenere una crema.
Impiattamento: Formare con le fette di mango una farfalla come base del piatto. Disporvi sopra le code di gamberoni e condire con la crema all'aceto balsamico. Accompagnare con l'aneto e la buccia del pomodoro secco.

3 king prawns
1 sprig of dill
3 sticks of chives
1 dried tomato
1 tbsp of extra virgin olive oil
3 drops of Modena balsamic vinegar
3 1/2 oz of mango

Peal the king prawns, remove the heads and legs and steam cook for two minutes.
Cut the mango in slices and put aside.
In an earthenware bowl mix the balsamic vinegar, olive oil and chives and whisk until it becomes a cream.
To serve: Create a bed of mango slices in a butterfly shape as the base of the dish. Place the king prawns tails on top and season with the balsamic cream. Accompany with dill and dried tomato.

3 Garnelen
1 Bund Dill
3 Stangen Schnittlauch
1 getrocknete Tomate
1 EL natives Olivenöl Extra
3 Tropfen Modena-Balsamico-Essig
100 g Mango

Die Garnelen schälen, die Köpfe und die Beine entfernen und zwei Minuten im Dampf kochen. Die Mango in Scheiben schneiden und zur Seite stellen. In einer Schale den Balsamico-Essig, das Olivenöl und den Schnittlauch mischen und zu einer Creme verrühren. Serviervorschlag: Die Mangoscheiben in Form eines Schmetterlings auf dem Teller verteilen. Darüber die Garnelenschwänze verteilen und mit der Öl-Essig-Creme anmachen. Mit Dill und der getrockneten Tomate garnieren.

3 langoustines
1 brin d'aneth
3 brins de ciboulettes
1 tomate séchée
1 c. à soupe d'huile d'olive vierge-extra
3 gouttes de vinaigre balsamique de Modène
100 g de mangue

Peler les langoustines et après avoir ôter la tête et les pattes, les cuire à la vapeur pendant deux minutes. Couper la mangue en tranches et réserver. Dans un bol, mélanger le vinaigre balsamique, l'huile d'olive et la ciboulette. Fouetter jusqu'à obtention d'une crème. Service : Arranger sur l'assiette les tranches de mangue en forme de papillon. Y déposer les queues de langoustine. Les arroser de crème balsamique. Agrémenter d'aneth et d'une tomate séchée.

3 langostinos
1 ramita de eneldo
3 ramitas de cebollino
1 tomate seco
1 cucharada de aceite de oliva extravirgen
3 gotas de vinagre balsámico de Módena
100 g de mango

Pelar los langostinos, desechar las cabezas y las patas y cocer al vapor durante dos minutos. Cortar el mango en rodajas y reservar. En un cuenco mezclar el vinagre balsámico, el aceite de oliva y el cebollino y batir hasta conseguir una crema. Emplatado: Formar con las rodajas de mango una mariposa como base del plato. Montar encima las colas de langostino aliñar con la crema balsámica. Acompañar con eneldo y tomate seco.

Light

Design: Gian Maria Torno I Chef: Fabio Dana

Via Maroncelli 8 I 20155 Milan
Phone: +39 02 62690631
www.milanorestaurants.it
Subway: Garibaldi
Opening hours: Mon–Sat 7 pm to 2 am
Average price: € 40 – € 50
Cuisine: International
Special features: Special cocktail bar varying with the seasons

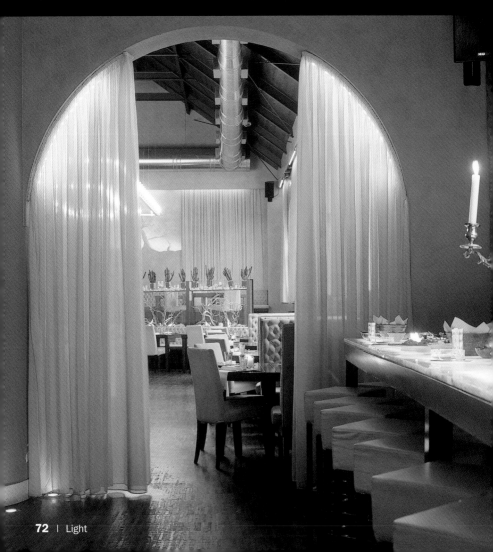

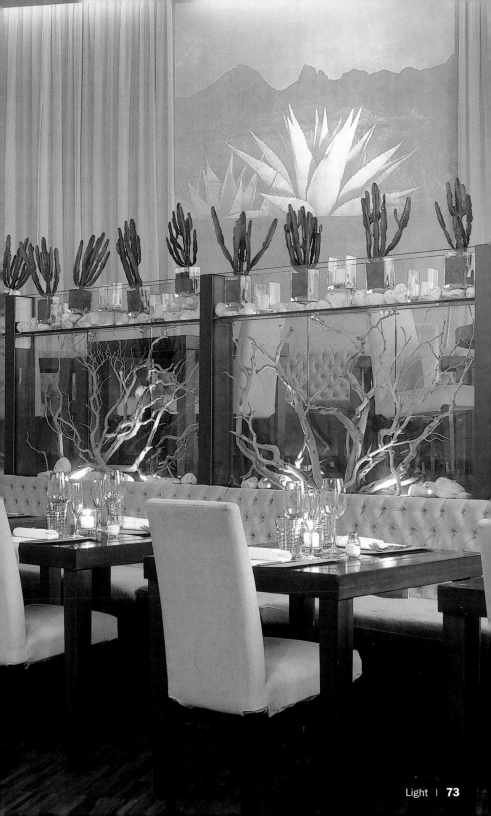

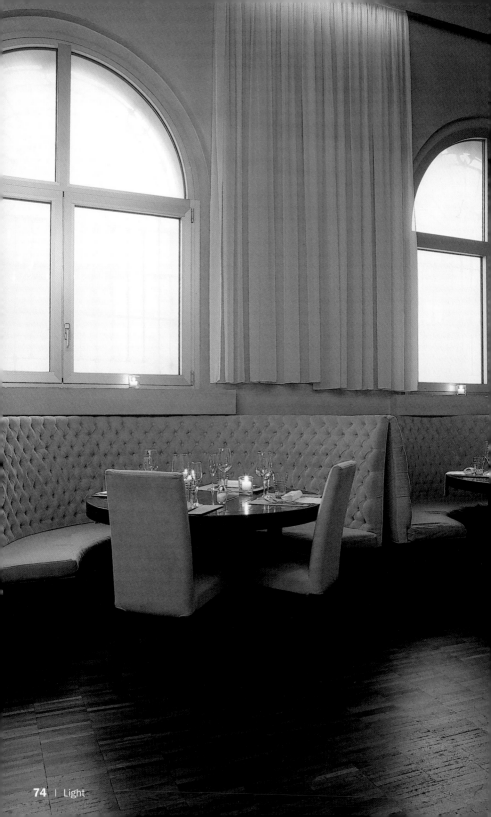

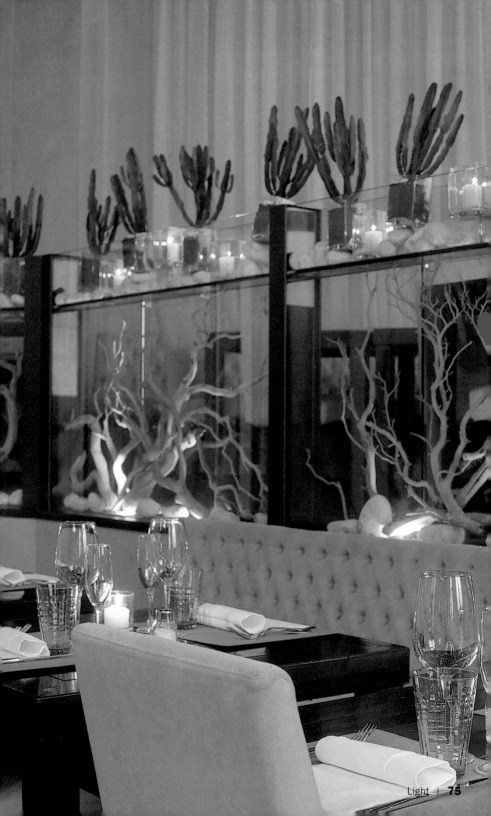

Rotolini di brie

con crema di zucchine

Brie Rolls with Cream of Courgettes

Brie-Röllchen mit Zucchinicreme

Petits rouleaux de brie à la crème
de courgettes

Rollitos de brie con crema de calabacín

4 rotolini di brie e prosciutto
4 zucchine
1/2 cipolla
100 ml brodo vegetale
8 fiori di zucchina
Farina
Olio d'oliva
Erbe aromatiche

Scaldare in un tegame un cucchiaio da minestra di olio e aggiungere la cipolla tagliata alla julienne e le zucchine. Trifolare il tutto e unire il brodo. Cuocere a fuoco lento e battere con la frusta fino ad ottenere una crema.
Friggere otto fiori di zucchina.
Infarinare i rotolini e dorarli leggermente in un tegame con un po' d'olio. Terminare la cottura al forno.
Impiattamento: Stendere uno strato sottile di crema in un piatto e disporvi sopra un rotolino.
Decorare con i fiori e spolverare con le erbe aromatiche.

4 rolls of brie and ham
4 courgettes
1/2 onion
100 ml vegetable stock
8 courgette flowers
Flour
Olive oil
Aromatic herbs

Heat a spoonful of oil in a casserole and add chopped onion julienne style and pieces of courgette chunks. Poach the stock. Cook on a low heat and blend in a blender until it becomes creamy.
Fry eight courgette flowers.
Flour the rolls and lightly brown in a frying pan with a little oil. Finish cooking rolls in the oven.
To serve: Spread a fine layer cream over the whole plate and arrange the rolls on top. Decorate with flowers and sprinkle aromatic herbs over the whole dish.

4 Röllchen aus Brie und Schinken
4 Zucchini
1/2 Zwiebel
100 ml Gemüsebrühe
8 Zucchiniblüten
Mehl
Olivenöl
Feine Kräuter

In einem Topf einen Suppenlöffel Öl erhitzen und die in Scheiben geschnittene Zwiebel und die gewürfelten Zucchini hinzugeben. Pochieren und die Brühe dazugeben. Bei langsamer Hitze kochen und mit dem Mixer zu einer Creme verquirlen.
Acht Zucchiniblüten anbraten.
Die Röllchen in Mehl wälzen und in einer Pfanne mit nur wenig Öl leicht goldbraun anbraten. Im Ofen garen.
Serviervorschlag: Eine dünne Schicht Gemüsecreme auf einen Teller geben und ein Röllchen darauf setzen. Mit den Zucchiniblüten verzieren und feine Kräuter darüber streuen.

4 petits rouleaux de brie et jambon
4 courgettes
1/2 oignon
100 ml bouillon de légumes
8 fleurs de courgettes
Farine
Huile d'olive
Herbes aromatiques

Dans une casserole, faire chauffer une cuillère à soupe d'huile et ajouter l'oignon coupé en julienne et les morceaux de courgette. Y ajouter le bouillon. Faire cuire à feux doux et passer au mixer jusqu'à obtention d'une crème.
Faire frire huit fleurs de courgette.
Mettre de la farine sur les rouleaux et les faire dorer doucement dans une poêle avec un peu d'huile. Terminer la cuisson au four.
Service : Etaler une fine couche de crème sur l'assiette et y déposer un petit rouleau. Décorer de fleurs de courgettes et parsemer d'herbes aromatiques.

4 rollitos de brie y jamón
4 calabacines
1/2 cebolla
100 ml caldo vegetal
8 flores de calabacín
Harina
Aceite de oliva
Hierbas aromáticas

Calentar en una cazuela una cucharada sopera de aceite y añadir la cebolla cortada en juliana y los calabacines troceados. Pochar y agregar el caldo. Cocer a fuego lento y pasar por la batidora hasta obtener una crema.
Freír ocho flores de calabacín.
Enharinar los rollitos y dorarlos ligeramente en una sartén con un poco de aceite. Acabar de cocinarlos en el horno.
Emplatado: Extender una fina capa de crema en un plato y disponer encima un rollito. Decorar con las flores y espolvorear hierbas aromáticas.

Living

Design: Antonio Coppola I Chef: From Sergio Mei's School

Via Broggi 17 I 20129 Milan
Phone: +39 02 20240458
www.chandelier.it
Subway: Lima
Opening hours: 8 pm to 2 am; happy hour, 6:30 pm
Average price: € 80 – € 100
Cuisine: Mediterranean, eclectic
Special features: Enjoy colourful cocktails during the happy hour

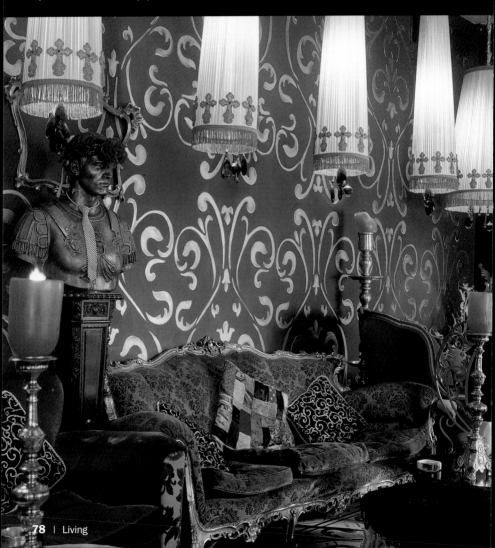

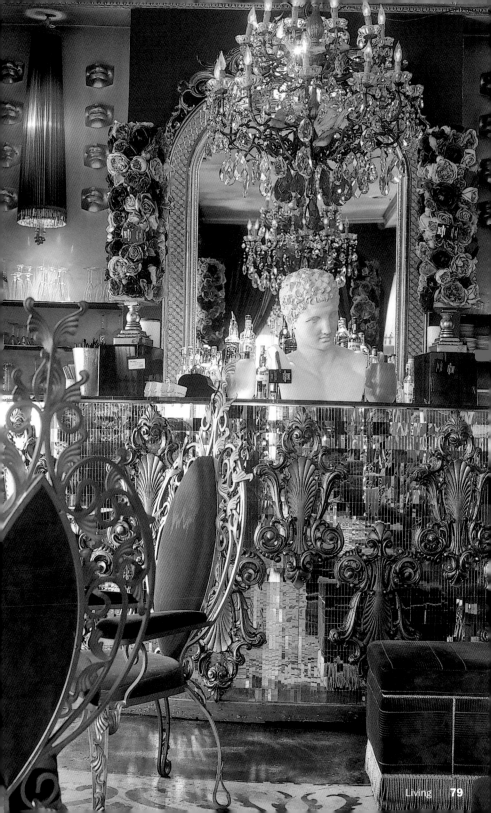

Brazilian Night

& Midori Sour

Brazilian Night:
120 ml di Batida de Coco
60 ml di vodka
20 ml di Blue Curaçao

Mettere in un bicchiere 5 o 6 cubetti di ghiaccio. Aggiungere gli ingredienti secondo il seguente ordine: Batida de Coco, vodka, Blue Curaçao. Agitare e versare in un bicchiere da Martini senza ghiaccio. Accompagnare con un alchechengi.

Midori Sour:
20 ml di succo di limone
20 ml di sciroppo di zucchero
120 ml di midori sour

Mettere in un bicchiere 5 o 6 cubetti di ghiaccio e aggiungere gli altri ingredienti del cocktail. Agitare e servire in una coppa capiente. Decorare con fettine d'arancia e foglie di menta.

Brazilian Night:
120 ml Batida de Coco
60 ml vodka
20 ml Blue Curaçao

Place 5 or 6 ice cubes in a glass. Add the ingredients in the following order: Batida de Coco, vodka, and Blue Curacao. Shake and pour into a Martini glass without ice. Accompany with alquequenje flower.

Midori Sour:
20 ml lemon juice
20 ml of sugar syrup
120 ml Midori Sour

Place 5 or 6 ice cubes in a glass and add all the ingredients to the cocktail. Shake and serve in around glass. Decorate with slices of orange and a few mint leaves.

Brazilian Night:
120 ml Batida de Coco
60 ml Wodka
20 ml Blue Curaçao

5 oder 6 Eiswürfel in ein Glas geben. Die Zutaten in folgender Reihenfolge dazugeben: Batida de Coco, Wodka, Blue Curaçao. Schütteln und in ein Martiniglas ohne Eis schütten. Mit einer Physalis (Lampionfrucht) verzieren.

Midori Sour:
20 ml Zitronensaft
20 ml Zuckersirup
120 ml Midori Sour

5 oder 6 Eiswürfel in ein Glas geben und die Zutaten für den Cocktail dazugeben. Schütteln und in einem bauchigen Glas servieren. Mit Orangenscheiben und Minzblättern dekorieren.

Brazilian Night:
120 ml de Batida de Coco
60 ml de Vodka
20 ml de Curaçao Bleu

Dans un verre, mettre 5 à 6 glaçons. Ajouter les ingrédients dans l'ordre suivant : Batida de Coco, Vodka et Curaçao bleu. Bien agiter et verser ensuite dans une coupe de Martini sans glaçon. Accompagner d'un amour en cage ou alkékenge.

Midori Sour:
20 ml de jus de citron
20 ml de sirop de sucre
120 ml de Midori Sour

Dans un verre, mettre 5 ou 6 glaçons et ajouter les ingrédients du cocktail. Agiter et servir dans un verre ballon. Décorer de rondelles d'orange et de quelques feuilles de menthe.

Brazilian Night:
120 ml de Batida de Coco
60 ml de vodka
20 ml de Blue Curaçao

Introducir en un vaso 5 o 6 cubitos de hielo. Añadir los ingredientes en el orden siguiente: Batida de Coco, vodka, Blue Curaçao. Agitar y verter en una copa tipo Martini sin hielo. Acompañar con un alquequenje.

Midori Sour:
20 ml de zumo de limón
20 ml de sirope de azúcar
120 ml de Midori Sour

Introducir en un vaso 5 o 6 cubitos de hielo y añadir los ingredientes del cóctel. Agitar y servir en una copa tipo globo. Decorar con rodajas de naranja y unas hojas de menta.

Lounge Il Foyer

Design: Pamela Babey I Chef: Sergio Mei

Four Seasons Hotel I Via Gesù 6-8 I 20121 Milan
Phone: +39 02 77088
www.fourseasons.com
Subway: San Babila, Montenapoleone
Opening hours: Mon–Sun 8:30 am to 1 am
Average price: € 18 – € 27
Cuisine: Mediterranean
Special features: Piano entertainment Monday to Saturday from 7:30 pm to 11:30 pm

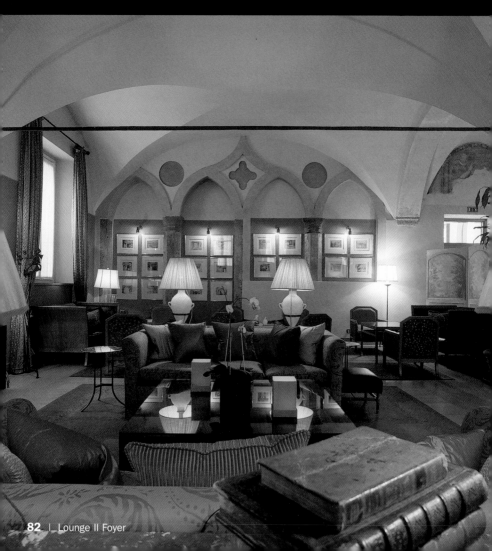

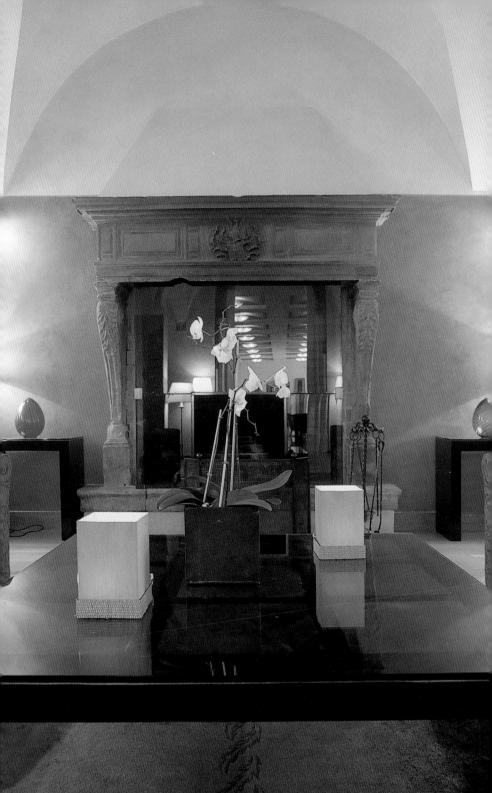

Cocktail Bellini

4 pesche bianche
Sciroppo di zucchero
Succo di limone

160 ml di succo di pesca
40 ml di succo di limone
Champagne

Frullare succo di pesca, le pesche, lo zucchero e il succo di limone appena prima di preparare il cocktail per evitare l'ossidazione naturale della frutta.

Cocktail: In uno shaker versare il frullato di pesca, un po' di ghiaccio e lo champagne. Mescolare il tutto con delicatezza per non eliminare il gas dello champagne.
Versare in un bicchiere il cocktail precedentemente raffreddato e aggiungere ancora un po' di champagne.
Decorare con una fettina sottile di pesca.

4 white peaches
Sugar syrup
Lemon juice

160 ml of peaches juice
40 ml of lemon juice
Champagne

Whisk peaches juice, the peaches, sugar and lemon juice before preparing the cocktail, to avoid the natural oxidation of the fruit.

Cocktail: Pour the peaches mix into a glass cocktail shaker, a little ice, and a sip of champagne. Mix delicately, to avoid eliminating the bubbles from the gas. Pour into a previously chilled glass and complete with a dash of champagne.
Decorate with a thin slice of peaches.

4 weiße Pfirsiche
Zuckersirup
Zitronensaft

160 ml Pfirsichsaft
40 ml Zitronensaft
Champagner oder Sekt

Pfirsichsaft, die Pfirsiche, den Zucker und den Zitronensaft vor Beginn der Zubereitung des Cocktails verquirlen, um die natürliche Oxidation der Frucht zu verhindern.

Cocktail: In einem Cocktailshaker aus Glas den Pfirsichmix, etwas Eis und einen Schluck Champagner oder Sekt geben. Vorsichtig mischen, damit der Sekt nicht die Kohlensäure verliert.
In ein vorgekühltes Cocktailglas geben und mit Sekt oder Champagner auffüllen.
Mit einer dünnen Pfirsichscheibe garnieren.

4 pêches blanches
Sirop de sucre
Jus de citron

160 ml de jus de pêche
40 ml de jus de citron
Champagne

Mixer le jus de pêches, les pêches, le sucre et le jus de citron avant de préparer le cocktail, pour éviter l'oxydation naturelle des fruits.

Cocktail : Dans un shaker en verre, verser la préparation à base de pêche, quelques glaçons et le sorbet au champagne. Mélanger le tout avec délicatesse, pour éviter d'éliminer les bulles de champagne.
Verser le cocktail refroidi dans une coupe et y ajouter un peu de champagne.
Décorer d'une fine tranche de pêche.

4 melocotones blancos
Sirope de azúcar
Zumo de limón

160 ml de zumo de melocotón
40 ml de zumo de limón
Champán

Batir el zumo de melocotón, los melocotones, el azúcar y el zumo de limón antes de la preparación del cóctel, para evitar así la oxidación natural de la fruta.

Cóctel: En una coctelera de cristal, verter el batido de melocotón, un poco de hielo y un sorbo de champán. Mezclarlo todo con delicadeza, para no eliminar el gas del champán.
Verter en una copa el cóctel previamente frío y completarlo con un toque de champán.
Decorar con una rodaja fina de melocotón.

Nobu

Design: Studio Gabellini | Chef: Shane McNeill

Via Pisoni 1 | 20121 Milan
Phone: +39 02 62312645
www.emporioarmani.com
Subway: Montenapoleone
Opening hours: Lunch, Tue–Sat from noon to 2:30 pm; dinner, Mon–Sat 7 pm to
11:30 pm; bar, noon to 4 pm, 6 pm to 1 am, Mondays 6:30 pm to 1 am
Average price: € 90
Cuisine: Traditional Japanese combined with South American and Californian influences
Special features: Catering service for cocktail parties

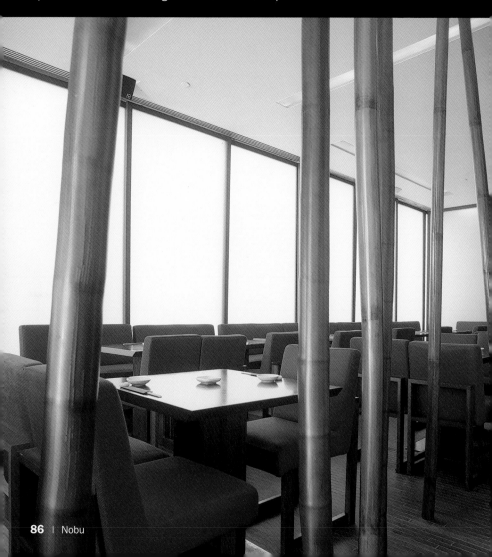

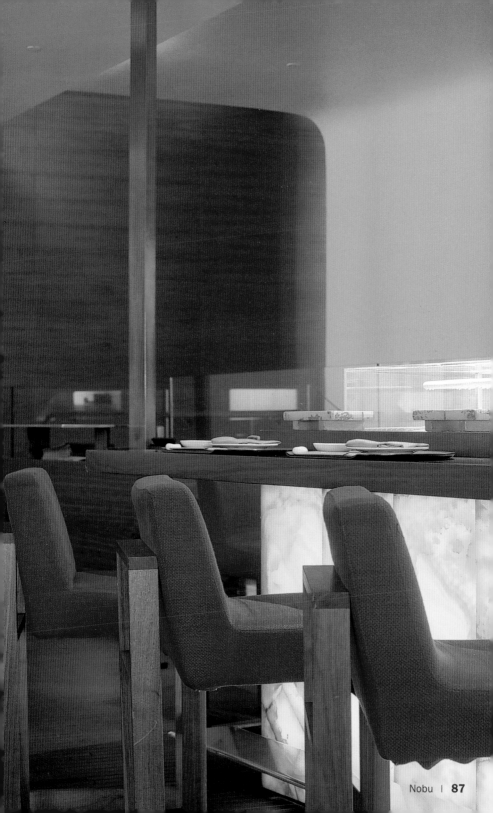

Aragosta in salsa
di pepe e wasabi

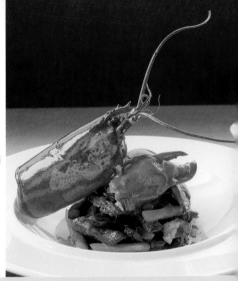

Lobster in Pepper and Wasabi Sauce
Languste in Pfeffer-Wasabi-Sauce
Langouste à la sauce poivrée et au wasabi
Langosta en salsa de pimienta y wasabi

1 aragosta
100 ml di burro chiarificato
1 spicchio d'aglio
4 asparagi verdi
200 g de champignon
Sale marino
Pepe nero
150 ml di salsa wasabi

Cuocere l'aragosta in acqua e sale per 5 minuti. Dopo averla lasciata raffreddare, sgusciarla e tagliare la coda in pezzi piccoli, di circa 2 cm di spessore.

In un tegame mettere il burro chiarificato e scaldare a fuoco medio. Aggiungere lo spicchio d'aglio a fettine. Quando comincia ad emanare il suo aroma, alzare il fuoco e aggiungere gli asparagi, tagliati precedentemente in pezzi da 5 cm, e gli champignon a tocchetti. Salare.
Quando le verdure hanno raggiunto il giusto punto di cottura, aggiungere i pezzi di aragosta e condire velocemente con il wasabi. Togliere dal fuoco.

1 lobster
100 ml of liquid butter
1 garlic clove
4 green asparagus
7 oz of mushrooms
Marine salt
Black pepper
150 ml of wasabi sauce

Boil the lobster in salted water for 5 minutes. Once cold, remove the meat and cut the tail into fine slices about 1 in. thick.

In a frying pan pour the butter and place on a medium heat. Add the previously sliced garlic clove. When the aroma begins to emanate, turn up the heat and add the previously sliced pieces (about 2 in. thick) of asparagus with the chopped mushrooms. Add salt and pepper.
When the vegetables are almost ready, add the slices of lobster and sauté quickly with the wasabi sauce. Remove from the heat.

1 Languste
100 ml geklärte Butter
1 Knoblauchzehe
4 Stangen grüner Spargel
200 g Pilze
Meersalz
Schwarzer Pfeffer
150 ml Wasabi

Die Languste 5 Minuten lang in Salzwasser kochen. Abkühlen lassen, das Fleisch herauslösen und den Schwanz in dünne Scheiben von etwa 2 cm Dicke schneiden.

Die geklärte Butter in eine Pfanne geben und bei mittlerer Hitze erwärmen. Die in Scheibchen geschnittene Knoblauchzehe hinzugeben. Wenn der Knoblauch sein Aroma zu entfalten beginnt, die Hitze erhöhen und den in 5 cm dicke Stücke geschnittenen Spargel und die fein geschnittenen Pilze hinzugeben. Mit Salz und Pfeffer abschmecken.
Wenn das Gemüse gar ist, die Langustenscheiben dazugeben und schnell mit Wasabi würzen. Vom Feuer nehmen.

1 langouste
100 ml de beurre allégé
1 gousse d'ail
4 asperges vertes
200 g de champignons
Sel de mer
Poivre noir
150 ml de sauce wasabi

Jeter la langouste dans l'eau bouillante salée et laisser cuire pendant 5 minutes. Une fois refroidie, ôter la carapace et couper la queue en fines rondelles de 2 cm d'épaisseur.

Dans une poêle, verser le beurre allégé et faire chauffer à feu moyen. Ajouter la gousse d'ail émincée. Quand l'arôme se dégage, augmenter la température et ajouter les asperges, coupées au préalable en morceaux de 5 cm d'épaisseur ainsi que les champignons également coupés en morceaux. Saler et poivrer.
Quand les légumes sont cuits à point, ajouter les rondelles de langouste et faire revenir rapidement avec le wasabi. Retirer du feu.

1 langosta
100 ml de mantequilla aclarada
1 diente de ajo
4 espárragos verdes
200 g de setas
Sal marina
Pimienta negra
150 ml de salsa wasabi

Hervir la langosta en agua con sal durante 5 minutos. Una vez fría, descarnarla y cortar la cola en rodajas finas, de unos 2 cm de grosor.

En una sartén verter la mantequilla aclarada y calentar a fuego medio. Añadir el diente de ajo laminado. Cuando emane su aroma subir el fuego y añadir los espárragos, que se habrán troceados en piezas de unos 5 cm de grosor, y las setas también troceadas. Salpimentar.
Cuando las verduras estén en su punto, añadir las rodajas de langosta y saltear rápidamente con el wasabi. Retirar del fuego.

Via Soresina 4 I 20144 Milan
Phone: +39 02 48110375
www.noyweb.com
Subway: Pagano, Conciliazione
Opening hours: Tue–Sun 6:00 pm to 2:00 am
Average price: 6 € – 16 €
Cuisine: Cocktails
Special features: Original happy hour

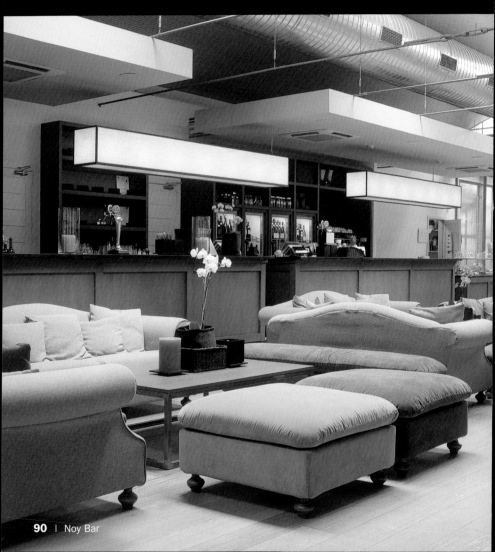

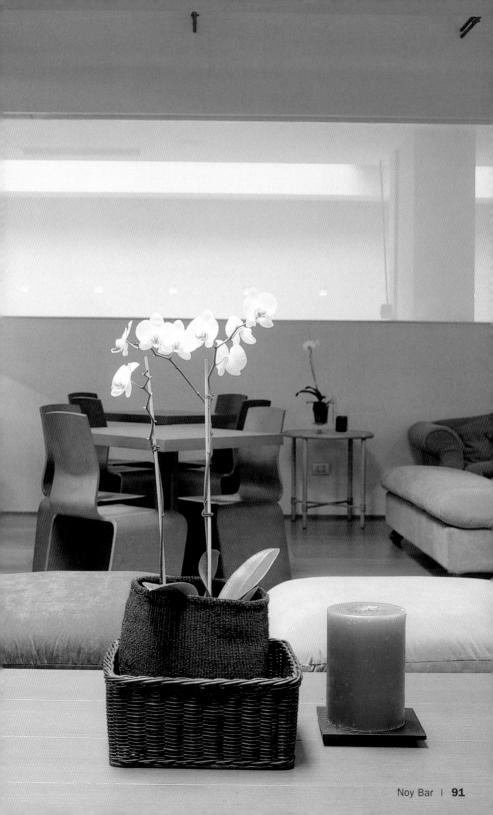

Cocktail Noy

15 g di zucchero di canna
2 mandarini cinesi
2 fette di limone
2 foglie di menta
Succo d'ananas

Spremere i mandarini cinesi e le fette di limone e mescolarle con lo zucchero. Versare il risultato ottenuto in un bicchiere e aggiungere un po' di succo d'ananas. Decorare con ananas al naturale e foglie di menta.

3 tsp of sugar cane
2 china mandarines
2 lemon slices
2 mint leaves
Pineapple juice

Squeeze the china mandarins and lemon and mix with the sugar. Pour the juice into a short glass and add a little pineapple juice. Decorate with pineapple and mint leaves.

15 g Rohrzucker
2 chinesische Mandarinen
2 Zitronenscheiben
2 Minzblätter
Ananassaft

Die chinesischen Mandarinen und die Zitronenscheiben ausdrücken und mit dem Zucker mischen. Die Mischung in ein Glas schütten und etwas Ananassaft dazugeben. Mit frischer Ananas und Minzblättern garnieren.

15 g de sucre de canne
2 mandarines de Chine
2 rondelles de citron
2 feuilles de menthe
Jus d'ananas

Presser les mandarines de Chine et les rondelles de citron et les mélanger au sucre. Verser le mélange obtenu dans un verre et ajouter un peu de jus d'ananas. Décorer d'un morceau d'ananas et de feuilles de menthe.

15 g de azúcar de caña
2 mandarinas chinas
2 rodajas de limón
2 hojas de menta
Zumo de piña

Exprimir las mandarinas chinas y las rojas de limón y mezclarlas con el azúcar. Verter el resultado obtenido en una copa y añadir un poco de zumo de piña. Decorar con piña natural y hojas de menta.

Noy

Design: Silvio Maglione | Chef: Alfonso Montefusco

Via Soresina 4 | 20144 Milan
Phone: +39 02 48110375
www.noyweb.com
Subway: Pagano, Conciliazione
Opening hours: Tue–Sun noon to 3 pm and 8 pm to midnight
Average price: € 15 – € 20
Cuisine: Mediterranean and international
Special features: Sunday brunch in the morning and aperitif in the evening

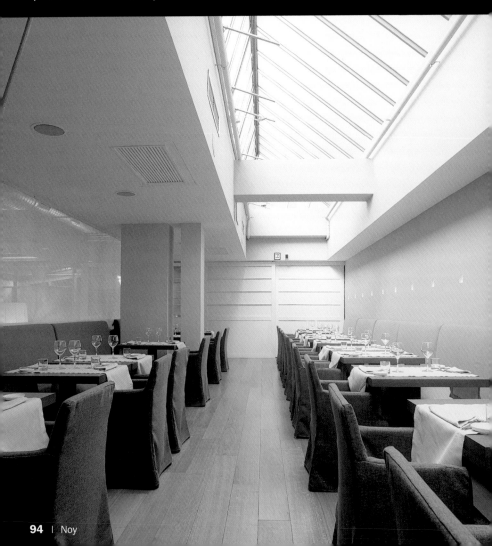

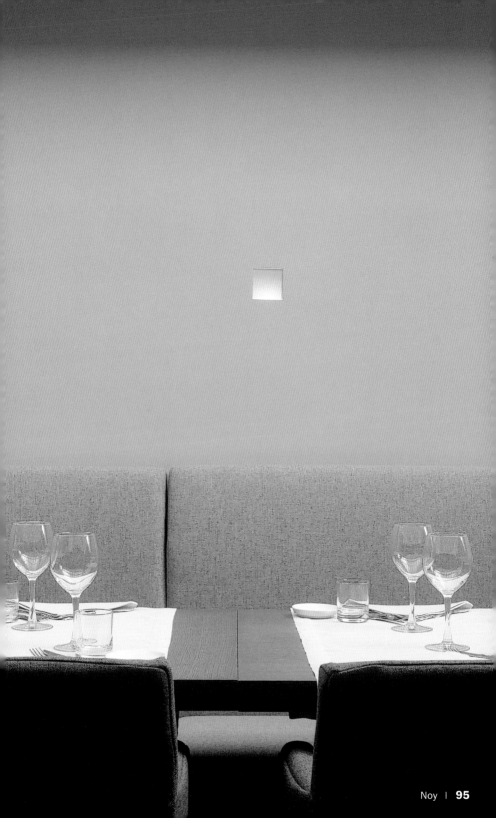

Millefoglie vegetale

Vegetable Millefeuille

Mille-feuille von Gemüse

Mille-feuille aux légumes

Milhojas vegetal

1 zucca
1 carota
100 g di formaggio affumicato
15 ml di olio d'oliva extravergine
90 ml olio d'oliva normale
Olio di girasole
Sale e pepe
1 pomodoro
3 barrette di riso soffiato
Basilico

Tagliare la zucca e la carota alla julienne e frig-gerle separatamente in un tegame con olio d'o-liva. Tagliare il formaggio a fettine sottili.
Friggere le barrette di riso soffiato in olio di gira-sole.
Tagliare il pomodoro a dadini e conservarlo per la decorazione del piatto.
Impiattamento: Disporre a torre tutti gli ingre-dienti iniziando con le verdure, il riso soffiato e alla fine il formaggio. Servire con pomodoro, foglie di basilico e olio d'oliva.

1 pumpkin
1 carrot
3 1/2 oz smoked cheese
15 ml extra virgin olive oil
90 ml standard olive oil
Sunflower oil
Salt and pepper
1 tomato
3 rice cakes
Basil

Cut the pumpkin and carrot julienne style and fry individually with olive oil. Cut the cheese into thin strips and put aside.
Fry the rice cakes in sunflower oil.
Dice the tomato into small cubes and put aside for decoration.
To serve: Make a tower with all the ingredients, starting with the vegetables, followed by the rice cakes, and lastly the cheese. Serve with toma-to, strips of basil and olive oil.

1 Kürbis
1 Karotte
100 g Räucherkäse
150 ml natives Olivenöl Extra
90 ml normales Olivenöl
Sonnenblumenöl
Salz und Pfeffer
1 Tomate
3 Reiskekse
Basilikum

Den Kürbis und die Karotte in Scheiben schneiden und einzeln mit Olivenöl in einer Pfanne anbraten. Den Käse in feine Streifen schneiden und zur Seite stellen. Die drei Reiskekse in Sonnenblumenöl anbraten. Die Tomate in kleine Würfel schneiden und für die Dekoration zur Seite stellen. Serviervorschlag: Auf einem Teller alle Zutaten turmförmig anordnen, unten das Gemüse, dann die Kekse und ganz oben der Käse. Mit Tomate, Basilikum-Streifen und Olivenöl garnieren.

1 potiron
1 carotte
100 g de fromage fumé
15 ml d'huile d'olive vierge extra
90 ml huile d'olive normale
Huile de tournesol
Sel et poivre
1 tomate
3 galettes de riz
Basilic

Couper le potiron et la carotte en julienne et les faire frire séparément dans une poêle. Avec de l'huile d'olive. Couper le fromage en fines lanières et réserver. Faire frire les galettes de riz dans de l'huile de tournesol. Couper la tomate en petits dés et la réserver pour la décoration. Service : Sur une assiette, empiler tous les ingrédients en commençant par les légumes puis par les galettes et finir par le fromage. Accompagner de tomates, du basilic émincé et d'huile d'olive.

1 calabaza
1 zanahoria
100 g de queso ahumado
15 ml de aceite de oliva extra
90 ml aceite de oliva normal
Aceite de girasol
Sal y pimienta
1 tomate
3 galletas de arroz inflado
Albahaca

Cortar la calabaza y la zanahoria en juliana y freírlas en una sartén individualmente con aceite de oliva. Cortar el queso en tiras finas y reservarlo. Freír las galletas de arroz inflado en aceite de girasol. Cortar en dados menudos el tomate y reservarlo para la decoración. Emplatado: Disponer en un plato a modo de torre todos los ingredientes, empezando por las verduras, seguidas de las galletas y, por último, el queso. Servir con tomate, albahaca en láminas y aceite de oliva.

Plateau

Design: Gian Maria Torno I Chef: Nando Pezzoli

Via A. Volta 3 I 20121 Milan
Phone: +39 02 6554108
www.milanorestaurants.it
Subway: Moscova
Opening hours: Mon–Sat 8 pm to midnight
Average price: € 40 – € 50
Cuisine: Seafood
Special features: Specialized in all seafoods, tartare and carpaccio; you definitely have to try Plateau Royal, a combination of fine seafoods

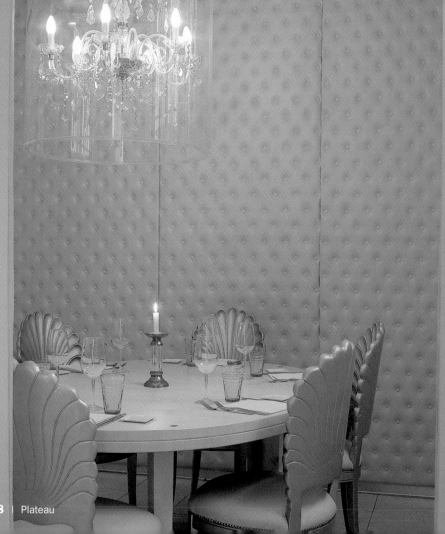

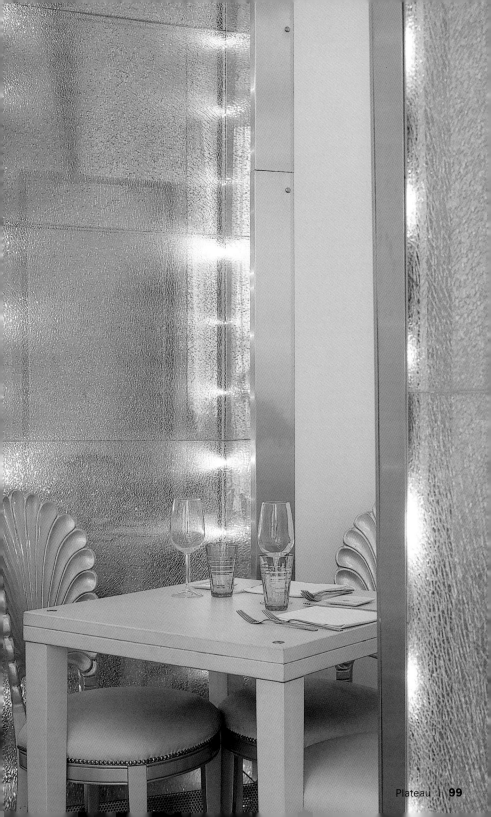

Spaghetti alla

chitarra con calamaretti

Chitarra Style Spaghetti with Baby Squid
Spaghetti Chitarra mit Babytintenfischen
Spaghettis « à la chitarra » aux calmars
Espaguetis a la chitarra con chipirones

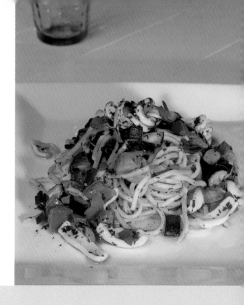

500 ml di brodo di pesce
320 g di spaghetti alla chitarra
320 g di calamaretti
200 g di zucchine
1 mazzetto di prezzemolo
1 spicchio d'aglio
120 g di pomodori maturi svuotati e tagliati a
dadini piccoli
Sale
Pepe

Pestare l'aglio e il prezzemolo. Scaldare un po'
di olio d'oliva in un tegame e saltare i calama-
retti con il battuto preparato precedentemente.
Friggere per un minuto e aggiungere poi il brodo
di pesce. Unire anche la zucchina, pulita e
tagliata a tocchetti senza togliere la scorza.
Cuocere gli spaghetti in acqua salata per alcuni
minuti mescolando di tanto in tanto e versarli
successivamente in una casseruola con il brodo
di pesce e i zucchine. Cuocere finché il brodo di
pesce si riduce a una salsa cremosa, aggiunge-
re i pomodori tagliati a dadini e servire ben
caldo.

500 ml fish stock
11 oz chitarra style spaghetti
11 oz baby squid
7 oz courgettes
1 bunch of parsley
1 garlic clove
4 oz parra tomato emptied and cut in small
chunks
Salt
Pepper

Chop the garlic and parsley. Heat a little olive oil
in a frying pan and sauté the baby squid with the
garlic and parsley. Fry for a minute and add the
fish stock. Clean and chop the courgettes.
Pre cook the pasta in salted water for a few
minutes and after pour them into a casserole
with the fish stock and the courgettes. Cook
until the stock is reduced to a creamy sauce,
add diced tomatoes and serve hot.

500 ml Fischbrühe
320 g Spaghetti Chitarra
320 g Babytintenfische
200 g Zucchini
1 Bund Petersilie
1 Knoblauchzehe
120 g Strauchtomaten, ausgehöhlt und in kleine
Würfel geschnitten
Salz
Pfeffer

Knoblauch und Petersilie fein hacken. Etwas Olivenöl in einer Pfanne erhitzen und die Baby-tintenfische mit der gehackten Knoblauch-Peter-silie-Mischung anbraten. Eine Minute anbraten und anschließend die Fischbrühe dazugeben. Die Zucchini säubern und mit Haut würfeln und dazugeben. Die Spaghetti in Salzwasser einige Minuten vor-kochen und danach zu der Fischbrühe und den Zucchini geben. Kochen lassen, bis die Fisch-brühe zu einer cremigen Sauce eingekocht ist und die gewürfelten Tomaten hinzugeben. Warm servieren.

500 ml de court-bouillon
320 g de Spaghettis « à la chitarra »
320 g de calmars
200 g de courgettes
1 bouquet de persil
1 gousse d'ail
120 g de tomates en branche vidées et coupées en petits dés
Sel
Poivre

Emincer l'ail et le persil. Faire chauffer un peu d'huile dans une poêle et faire revenir les cala-mars avec l'émincé. Faire frire pendant une mi-nute et ajouter le court-bouillon. Ajouter aussi les courgettes bien nettoyé et coupé en mor-ceaux sans ôter la peau. Pré cuire les spaghettis dans de l'eau bouillan-te salée pendant quelques minutes et les met-tre ensuite dans la casserole avec le court-bouillon et les courgettes. Faire cuire jusqu'à ce que le court-bouillon réduise et devienne une sauce crémeuse, ajouter les tomates coupées en dés et servir chaud.

500 ml de caldo de pescado
320 g de espaguetis a la chitarra
320 g de chipirones
200 g de calabacín
1 manojo de perejil
1 diente de ajo
120 g de tomates de parra vaciados y cortados en tacos pequeños
Sal
Pimienta

Picar el ajo y el perejil. Calentar un poco de acei-te de oliva en una sartén y saltear los chipiro-nes con la picada que se ha preparado. Freír du-rante un minuto y añadir el caldo de pescado. Agregar también el calabacín, bien limpio y tro-ceado sin desechar la piel. Precocinar los espaguetis en agua salada hir-viendo durante algunos minutos y posteriormen-te verterlos en la cazuela con el caldo de pes-cado y los calabacines. Cocer hasta que el caldo de pescado se haya reducido a una salsa cremosa, añadir los tomates cortados en dados y servir caliente.

Raw Fish Café

Design: The owners | Chef: Limonta

Via Martiri Oscuri 19 | 20125 Milan
Phone: +39 02 28040396
www.rawfishcafe.it
Subway: Rovereto
Opening hours: noon to 3 am
Average price: € 40 – € 50
Cuisine: Italian style fish
Special features: Specialized in dishes with raw fish, happy hour 6:30 pm to 10:30 pm

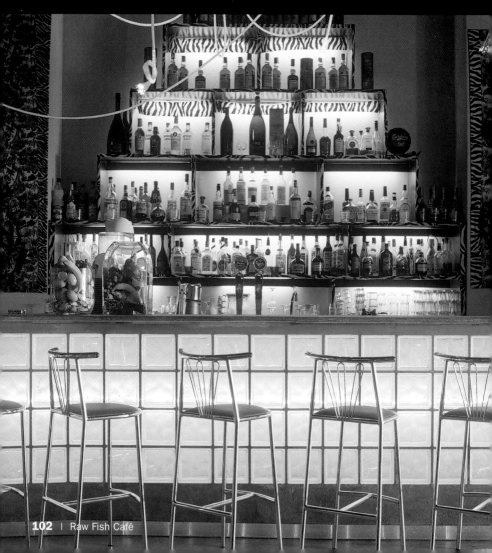

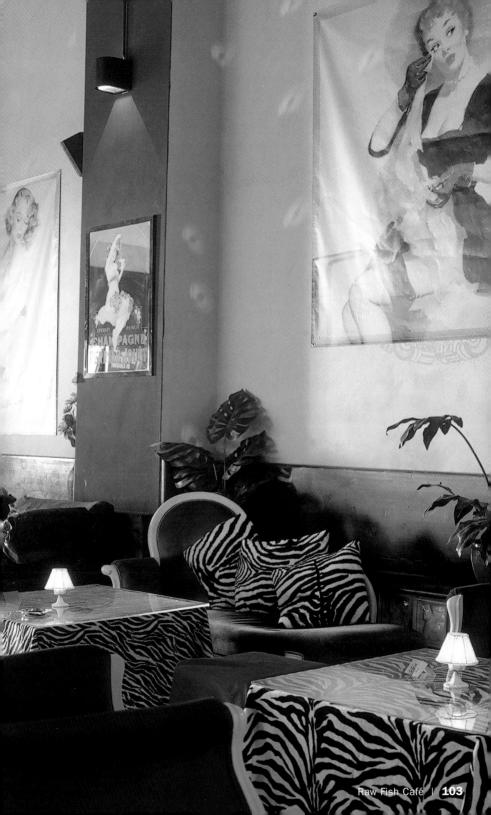

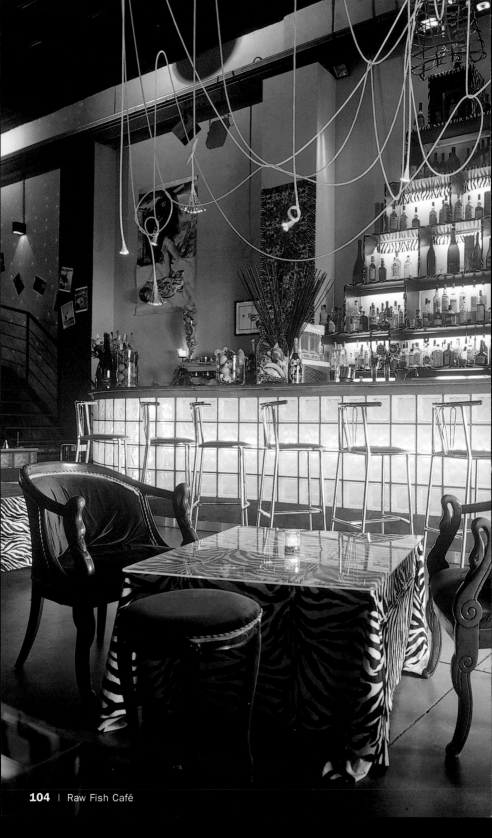

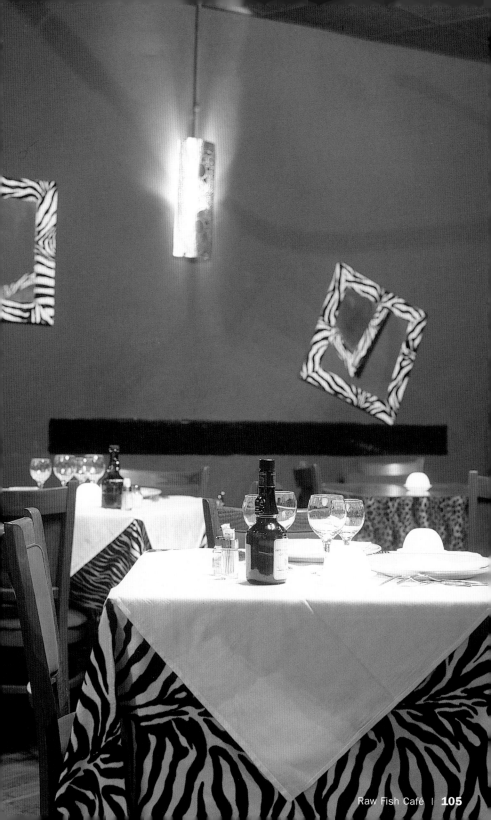

Via Ripamonti 337 | 20141 Milan
Phone: +39 02 5520194
www.shambalamilano.it
Subway: Capolinea
Opening hours: Tue–Sun 8 pm to 2 am
Average price: € 36
Cuisine: Vietnamese Thai
Special features: Zen garden

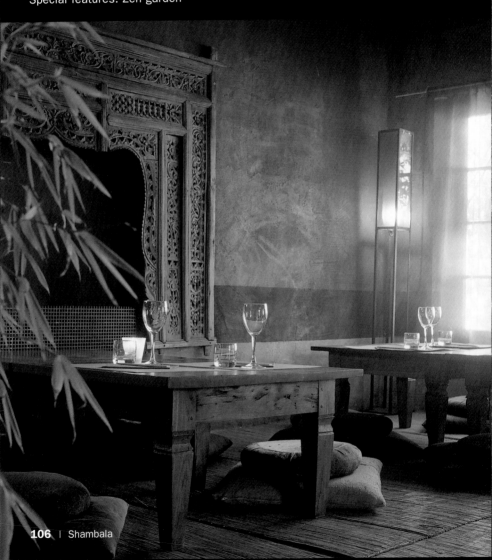

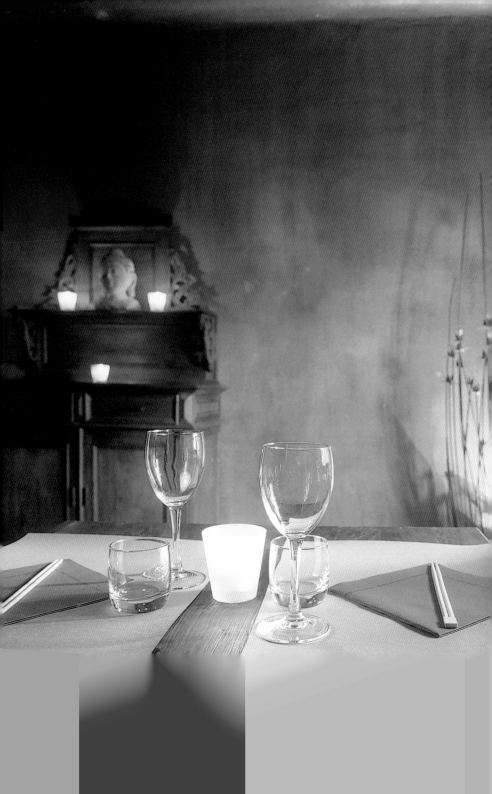

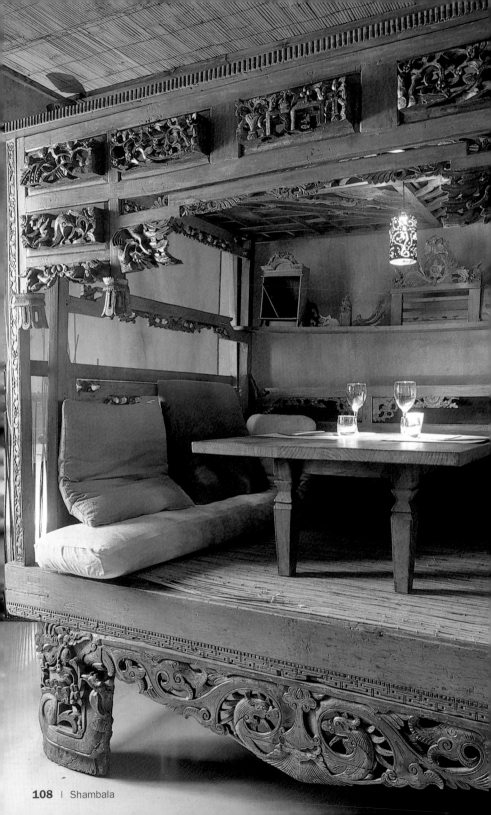

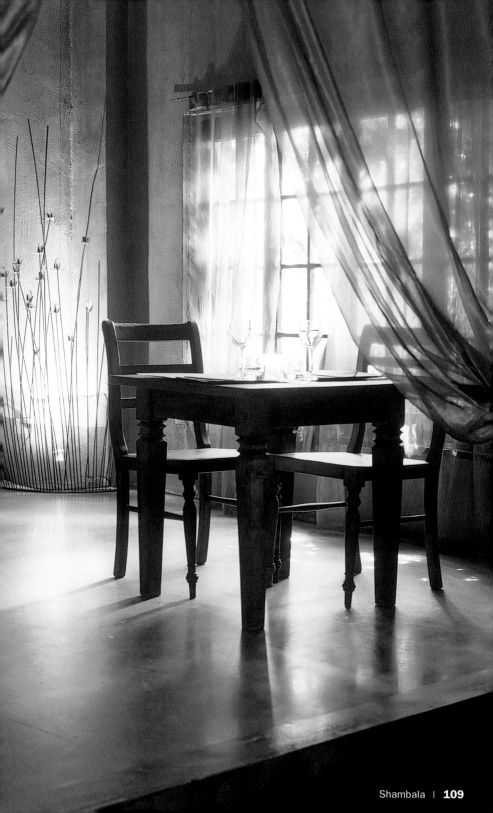

Rosa di salmone

Salmon Rose
Lachsrose
Rose de saumon
Rosa de salmón

250 g di salmone fresco
1 fetta di ananas naturale
1 pera matura
Sale
Menta
Pepe rosa

Pulire, togliere la scorza e tagliare a pezzetti l'ananas e la pera e cuocerle al vapore. Quando perdono consistenza, disporre i pezzi di frutta in un recipiente e mescolarli con una forchetta fino ad ottenere una crema spessa.
Sfilettare il salmone e cuocerlo al vapore con un pizzico di sale.
Impiattamento: Stendere sul piatto una base di puré di frutta e disporvi sopra il salmone a forma di rosa dopo averlo lasciato raffreddare. Accompagnare con la menta tagliata sottile e il pepe rosa.

8 1/2 oz fresh salmon
1 slice of pineapple
1 mature pear
Salt
Mint
Red pepper

Clean, peal and cut the pineapple and pear and steam cook. Once they are completely soft, remove and place in a dish; beat with fork until a paste is achieved.
Finely fillet the salmon. Steam cook with a pinch of salt.
To serve: In a dish create a base with the fruit puree, once the salmon is cold place over the puree in the form of a rose. Accompany with mint cut julienne style and red pepper.

250 g frischen Lachs
1 Scheibe frische Ananas
1 reife Birne
Salz
Minze
Rosa Pfeffer

Die Ananas und die Birne säubern, schälen und in kleine Stücke schneiden und mit Dampf ko-chen, bis sie weich sind. In eine Schale geben und mit einer Gabel zu einem Brei verrühren. Den Lachs in feine Scheiben schneiden. Mit einer Prise Salz würzen und in Dampf garen. Serviervorschlag: Die Fruchtcreme auf dem Tellerboden verteilen und den abgekühlten Lachs in Form einer Rose darüber anordnen. Mit in Streifen geschnittener Minze und rosa Pfeffer garnieren.

250 g de saumon frais
1 rondelle d'ananas frais
1 poire mure
Sel
Menthe
Poivre rose

Laver, peler et trancher l'ananas et la poire et les faire cuire à la vapeur. Quand ils sont tendres, les retirer et les déposer dans un récipient. Les retourner sans cesse avec une fourchette jusqu'à obtention d'une pâte. Couper le saumon en fines tranches. Le faire cuire à la vapeur avec une pincée de sel. Service : Sur une assiette, étendre une couche de purée de fruits et parer de saumon refroidi en formant une rose. Agrémenter d'une julienne de menthe et de poivre rose.

250 g de salmón fresco
1 rodaja de piña natural
1 pera madura
Sal
Menta
Pimienta rosada

Limpiar, pelar y trocear la piña y la pera y cocerlas al vapor. Cuando estén completamente blandas, retirarlas y disponerlas en un recipiente; remover insistentemente con un tenedor hasta obtener un pasta. Filetear el salmón finamente. Cocinarlo al vapor con una pizca de sal. Emplatado: Disponer una base de puré de frutas en un plato y montar el salmón una vez frío formando una rosa. Acompañar con menta cortada en juliana y pimienta rosada.

Shu

Design: Fabio Novembre I Chef: Mane Gazmir

Via Molino delle Armi I 20122 Milan
Phone: +39 02 58315720
www.shucafe.it
Subway: Missori
Opening hours: Mon–Sun 6 pm to 9 pm
Average price: € 20 – € 35
Cuisine: Italian and Mediterranean
Special features: Discorestaurant, special events and performances such as
visual art nights

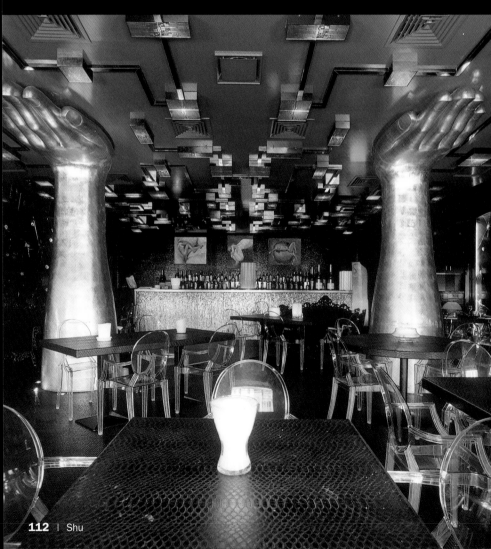

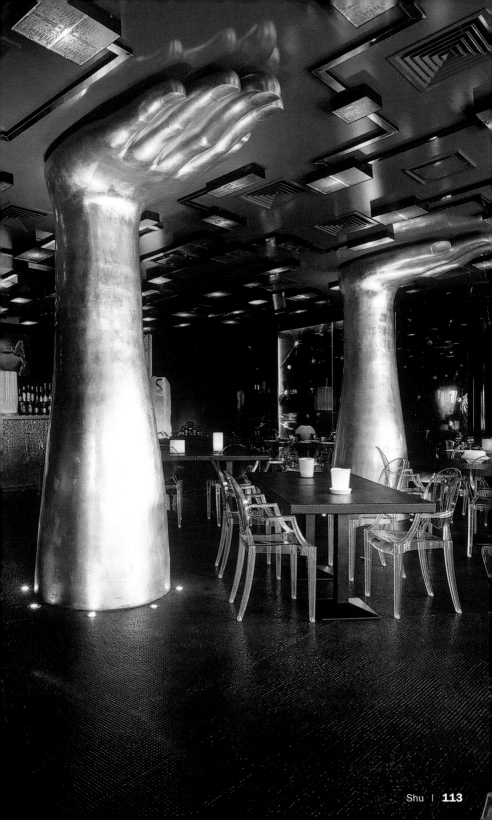

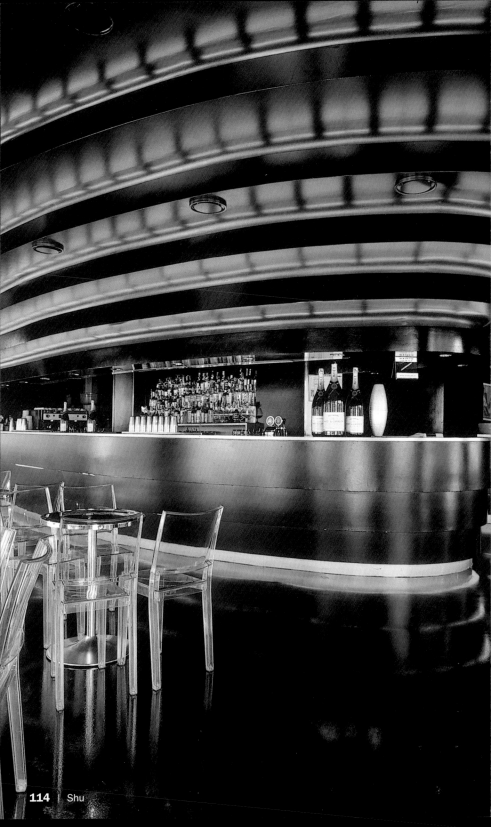

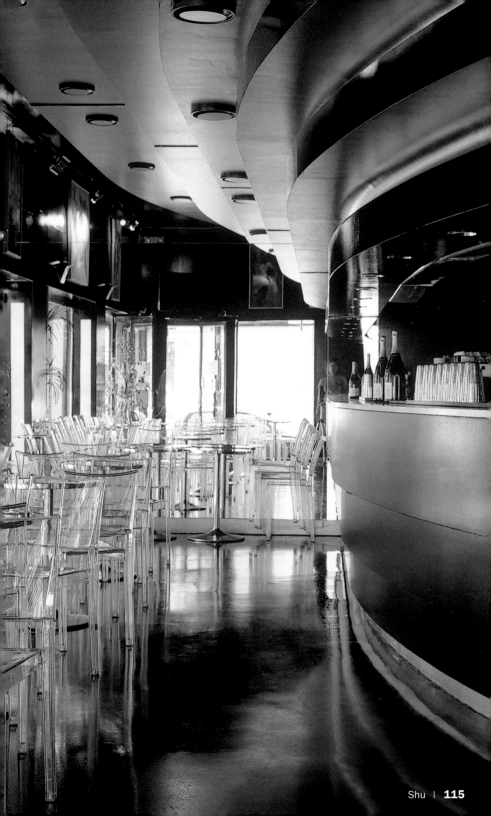

Sex on the Beach

100 ml di vodka
50 ml di liquore alla pesca
75 ml di succo d'ananas
10 ml di liquore ai lamponi
Mirtilli
1/2 limone

Mettere tutti gli ingredienti in uno shaker e agitare; servire in una coppa da champagne e decorare con mirtilli e fette di limone.

100 ml vodka
50 ml peach liquor
75 ml pineapple juice
10 ml raspberry liquor
Cranberries
1/2 lemon

Fill the cocktail mixer with all the ingredients and shake, serve in a champagne glass and decorate with cranberries and half a lemon.

100 ml Wodka
50 ml Pfirsichlikör
75 ml Ananassaft
10 ml Himbeerlikör
Heidelbeeren
1/2 Zitrone

Alle Zutaten in einen Cocktail-Shaker geben und schütteln. In einer Sektschale servieren und mit Heidelbeeren und der halben Zitrone verzieren.

100 ml de vodka
50 ml de liqueur de pêche
75 ml de jus d'ananas
10 ml de liqueur de framboise
Myrtilles
1/2 citron

Mettre tous les ingrédients dans un shaker et bien agiter. Servir dans une coupe à champagne et décorer de myrtilles et d'un demi citron.

100 ml de vodka
50 ml de licor de melocotón
75 ml de zumo de piña
10 ml de licor de frambuesa
Arándanos
1/2 limón

Introducir todos los ingredientes en una coctelera y agitar; servir en una copa de champán y decorar con arándanos y medio limón.

Straf Hotel

Design: Vincenzo de Cotiis

Via San Raffaele 3 | 20121 Milan
Phone: +39 02 805081
www.straf.it
Subway: Duomo
Opening hours: 11 am to midnight
Average price: € 15 – € 35
Cuisine: Italian, Mediterranean, light and inventive
Special features: Newest design in town, very fashionable

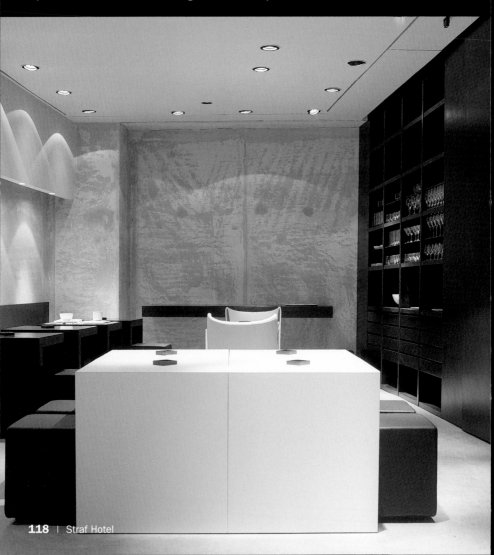

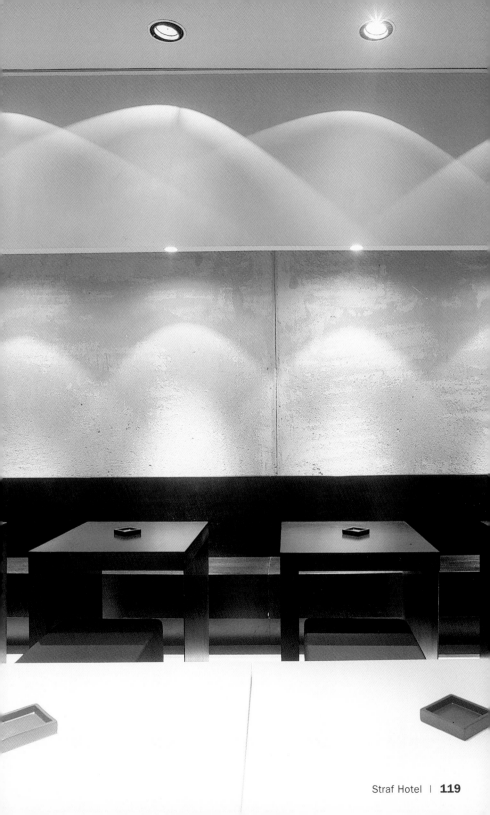

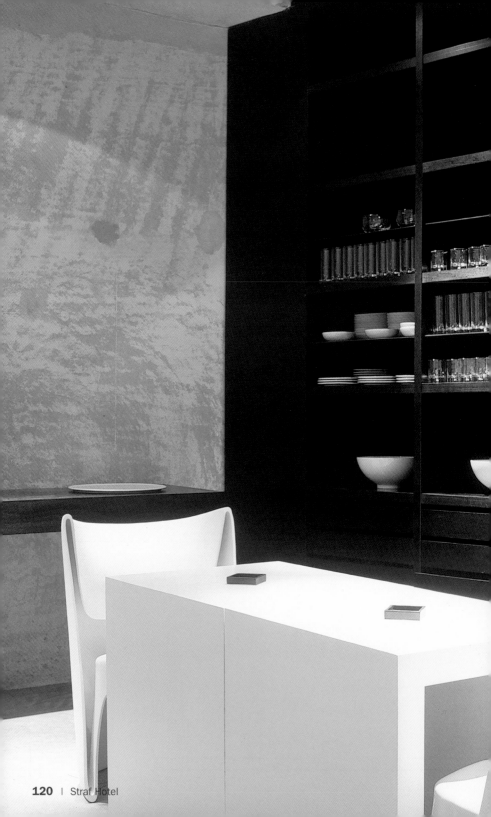

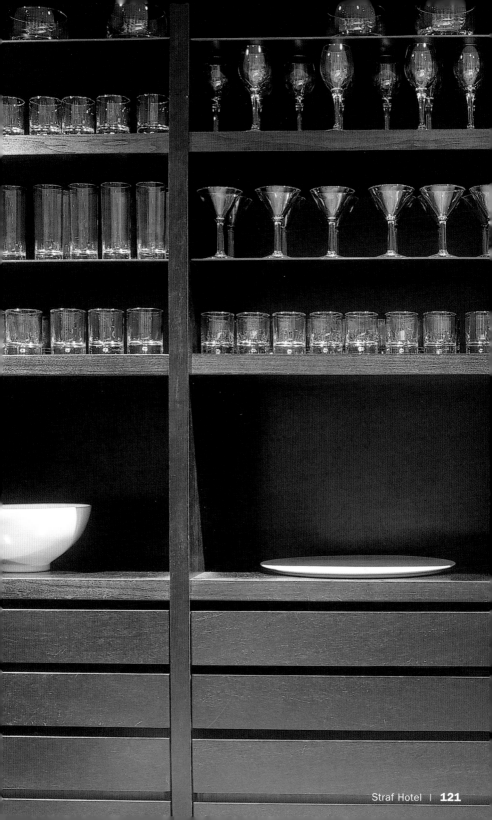

Insalata di granchio

Crab Salad

Krebssalat

Salade de crabe

Ensalada de cangrejo

100 g di polpa di granchio
1 arancia
Foglie di menta
Peperoncini
Prezzemolo tritato
Scorza di limone grattugiata

Sbucciare l'arancia staccando bene la pelle, in modo da togliere ogni residuo bianco dagli spicchi. Tagliarla a fettine.

Sminuzzare la polpa di granchio e riservare due pezzi per la decorazione.
Impiattamento: Formare un letto con le fettine d'arancia. Disporvi sopra la polpa di granchio a forma di cuore e formare una croce con i due pezzi avanzati. Decorare con alcune foglie di menta, prezzemolo tritato, peperoncino a pezzetti e scorza di limone grattugiata.

3 1/2 oz crab meat
1 orange
Mint leaves
Chillies
Chopped parsley
Graded lemon rind

Peal the interior and exterior skin of an orange and remove all white parts. Cut into slices.

Flake the crab meat and set aside two portions for the decoration.
To serve: Create a bed of orange slices and on top place the crab meat in a heart shape and create a cross with the two reserved portions. Decorate with mint leaves, chopped parsley, fileted chillis and lemon powder.

100 g Krebsfleisch
1 Orange
Minzblätter
Peperoni
Gehackte Petersilie
Geriebene Zitronenschale

Die Orange schälen und auch die weiße Haut vollständig entfernen. In Scheiben schneiden.

Das Krebsfleisch klein schneiden. Vorher zwei Stücke zum Garnieren zur Seite stellen. Serviervorschlag: Aus den Orangen ein Bett formen. Das Krebsfleisch auf den Orangen anrichten und die beiden beiseite gelegten Stücke in Kreuzform anordnen. Mit Minzblättern, gehackter Petersilie, einer fein geschnittenen Peperoni und geriebener Zitronenschale garnieren.

100 g de chair de crabe
1 orange
Feuilles de menthe
Piment rouge
Persil émincé
Zeste de citron

Peler soigneusement l'orange afin d'ôter la peau intérieure et extérieure. La chair des quartiers ne doit avoir aucune particule blanche. Couper en rondelles. Emietter la chair de crabe et réserver deux parts pour la décoration. Service : Faire un lit de rondelles d'oranges. Parer avec la chair de crabe en lui donnant une forme de cœur. Déposer les deux parts réservées, en formes de croix. Agrémenter de feuilles de menthe, de persil émincé, de lanières de piments et de zeste de citron.

100 g de carne de cangrejo
1 naranja
Hojas de menta
Guindillas
Perejil picado
Rayadura de limón

Pelar la naranja de forma que se deseche la piel exterior y la interior; la fruta no debe presentar ningún resto blanquecino adherido a los gajos. Cortarla a rodajas. Desmenuzar la carne de cangrejo y reservar dos porciones para la decoración. Emplatado: Formar un lecho con las rodajas de naranja. Montar encima la carne de cangrejo dándole forma de corazón y disponer en cruz las dos porciones reservadas. Decorar con unas hojas de menta, perejil picado, guindilla fileteada y polvo de limón.

Design: Patricia Auquiola and Marta de Rencio |
Chef: Luigi Moretti

Via Quintino Sella 2 | 20121 Milan
Phone: +39 02 861418
www.tinteroristorante.it
Subway: Lanza
Opening hours: noon to 3 pm and 7 pm to 2 am
Average price: € 35 – € 45
Cuisine: Mediterranean and seafood
Special features: Music bar

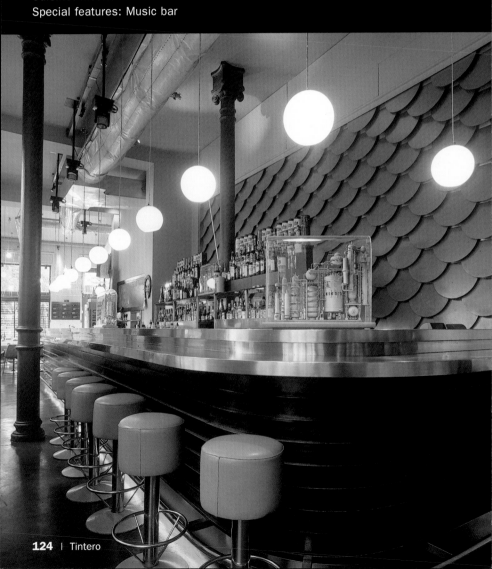

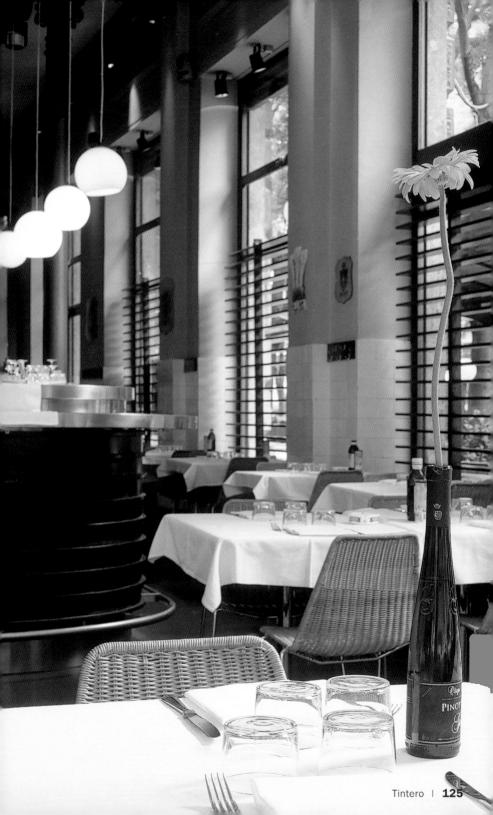

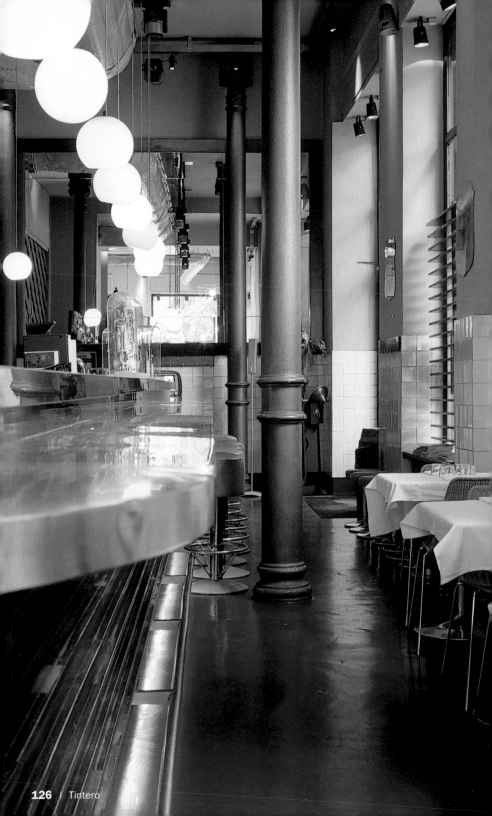

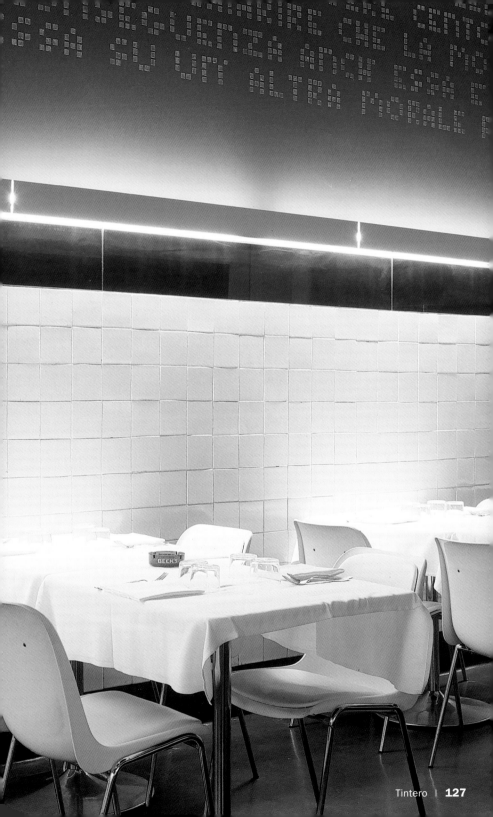

Yar

Design: Studio Sacci & Barazzetta I Chef: Matteo Calciati

Via Mercalli 22 I 20122 Milan
Phone: +39 02 58305234
www.yar.it
Subway: Crocetta, Missori
Opening hours: Mon–Sat 8 pm to 2 am
Average price: € 60 – € 80
Cuisine: Russian
Special features: On Tuesday evenings you can try French food and wine at the bistro

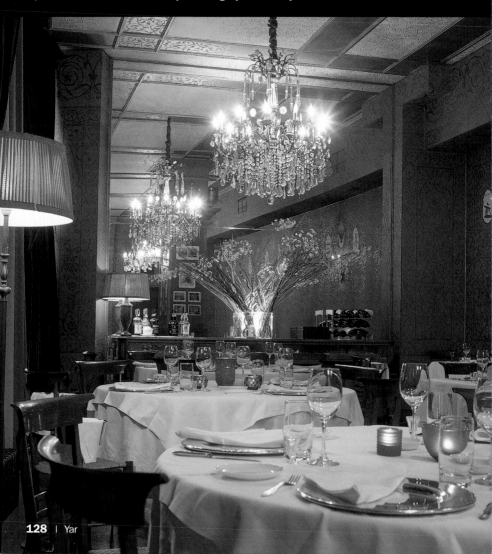

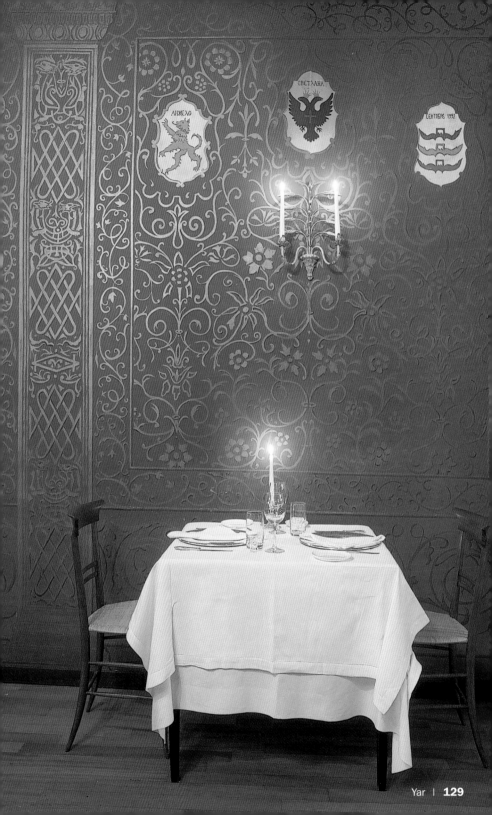

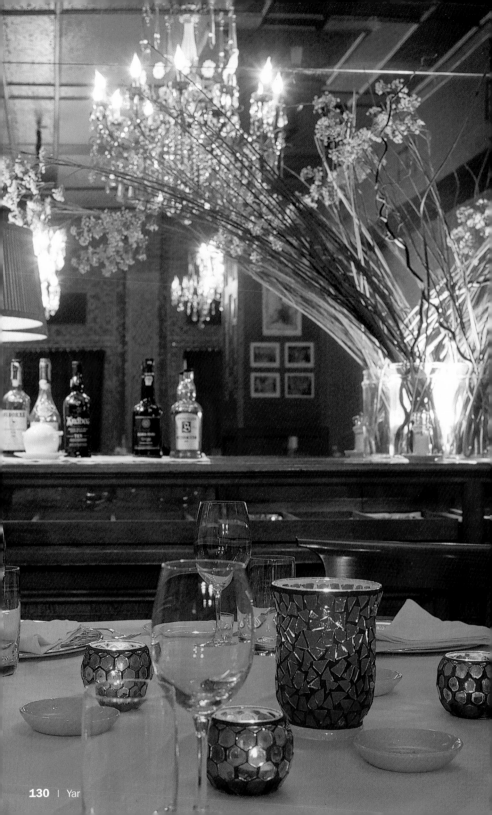

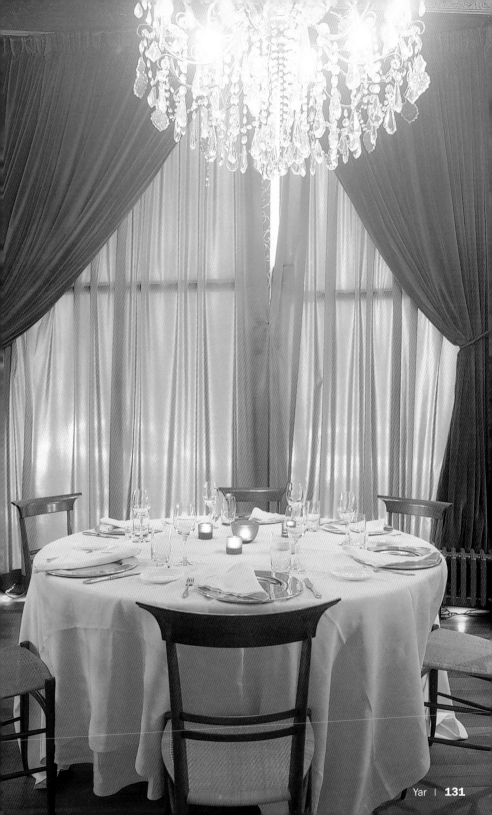

Tartare di salmone

e ricciola con crema dolce

Salmon Tartare and Serviola
with Sweet Cream

Lachstartar und Serviolafisch
mit süßer Creme

Tartare de saumon et sériole couronnée
à la crème douce

Tartar de salmón y serviola con crema dulce

70 g di salmone
70 g di ricciola
5 g di cipollotto
5 g di cerfoglio
45 ml di olio d'oliva
Succo di 1/2 limone
1/4 di mela
1/2 fico d'India
Sale e pepe
1/4 di zucchina
1/2 carota

In un recipiente ampio disporre il salmone e la ricciola precedentemente puliti e tagliati a toc-chetti. In una terrina mescolare il succo di limone, il cipollotto, il cerfoglio e l'olio e salare. Amalgamare bene e coprire i pesci con il composto per la marinatura. Lasciare riposare per 3 ore nel frigorifero dopo avere chiuso il recipiente con la pellicola trasparente.
Sbucciare la mela e tagliarla a pezzi. Cuocerla al vapore e passarla nel frullatore per ottenere una crema compatta. Ripetere il procedimento con il fico d'India.
Impiattamento: Creare con la crema di frutta una base circolare nel piatto. Disporvi sopra il pesce marinato e decorare con la zucchina e la carota tagliate a pezzetti molto piccoli.

2 1/2 oz salmon
2 1/2 oz serviola
1 tsp spring onion
1 tsp chervil
45 ml olive oil
Juice of 1/2 lemon
1/4 apple
1/2 fig
Salt and pepper
1/4 courgette
1/2 carrot

Arrange the salmon in a large container, clean and cut the serviola into small pieces and add to the dish. In a bowl mix the Lemon juice, spring onion, chervil, oil and add salt and pepper. Blend together well and cover the fish with the mixture and leave to marinate. Set aside for 3 hours in the fridge covered with cooking paper. Peal and chop the apple. Steam cook and grind with the blender until a thick and compact cream is achieved. Repeat the procedure with a fig.
To serve: Pour the cream in circular dish and arrange the marinated fish on top of the cream. Decorate with courgette and finely chopped carrots.

70 g Lachs
70 g Serviolafisch
5 g Frühlingszwiebeln
5 g Kerbel
45 ml Olivenöl
Saft einer halben Zitrone
1/4 Apfel
1/2 Kaktusfeige
Salz und Pfeffer
1/4 Zucchini
1/2 Karotte

Die gesäuberten und in kleine Stücke geschnittenen Fische in eine große Schüssel geben. In einer Schale den Zitronensaft, die Frühlings-zwiebel, den Kerbel und das Öl mischen und mit Salz und Pfeffer abschmecken. Gut verrühren und die Fischstücke mit der Marinade bedecken. Für 3 Stunden mit Plastikfolie abgedeckt im Kühlschrank ruhen lassen.
Den Apfel schälen und klein schneiden. Mit Dampf kochen und mit einem Mixer zu einer zähen Creme verrühren. Die Kaktusfeige ebenso verarbeiten.
Serviervorschlag: Die beiden Cremes kreisförmig als Basis auf dem Teller verteilen. Den marinierten Fisch darüber anordnen und mit den sehr fein geschnittenen Zucchini und Karotten garnieren.

70 g de saumon
70 g de sériole
5 g d'ognion tendre
5 g de cerfeuil
45 ml d'huile d'olive
Jus de 1/2 citron
1/4 de pomme
1/2 figue de Barbarie
Sel et poivre
1/4 de courgette
1/2 carotte

Dans un grand récipient, déposer le saumon et la sériole nettoyés au préalable et coupés en petits morceaux. Dans un bol, mélanger le jus de citron, l'ognion tendre, le cerfeuil et l'huile. Assaisonnez le tout de sel et poivre. Bien mélanger tous les ingrédients et couvrir les poissons de ce mélange. Recouvrir d'un film transparent et laisser mariner pendant 3 heures au frigidaire.
Peler la pomme et la couper en morceaux. La cuire à la vapeur et l'écraser dans le mixer jusqu'à obtention d'une crème onctueuse. Faire de même avec la figue de Barbarie.
Service : Superposer les crèmes en cercle au milieu de l'assiette. Y déposer au-dessus le poisson mariné et décorer de tous petits morceaux de courgette et de carotte.

70 g de salmón
70 g de serviola
5 g de cebolleta
5 g de perifollo
45 ml de aceite de oliva
Zumo de 1/2 limón
1/4 de manzana
1/2 higo chumbo
Sal y pimienta
1/4 de calabacín
1/2 zanahoria

En un recipiente amplio disponer el salmón y la serviola previamente limpios y cortados en trozos pequeños. En un bol mezclar el zumo de li-món, la cebolleta, el perifollo y el aceite y salpimentar. Amalgamar bien y cubrir los pescados con mezcla para marinar. Dejar reposar durante 3 horas en el frigorífico tapado con papel transparente.
Pelar la manzana y trocearla. Cocerla al vapor y triturarla con la batidora hasta conseguir una crema de consistencia compacta. Repetir el procedimiento con el higo chumbo.
Emplatado: Disponer una base circular en el plato superponiendo las cremas. Extender encima el pescado marinado y decorar con calabacín y zanahoria cortados en trozos muy pequeños.

14 1/2

Arco della Pace

Via Mario Pagano

Parco Sempione

9

Staz. Fer. Nord

◄ 18/19

Corso Vercelli

Via Papiniano

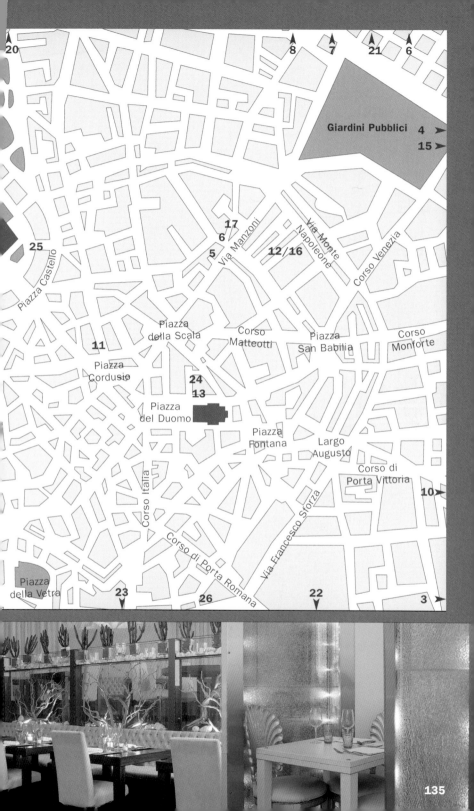

20

8 7 21 6

Giardini Pubblici 4 ►

15 ►

17

6

5 Via Manzoni 12/16

Via Monte Napoleone

Corso Venezia

25

Piazza Castello

Piazza della Scala

Corso Matteotti

Piazza San Babila

Corso Monforte

11

Piazza Cordusio

24

13

Piazza del Duomo

Piazza Fontana

Largo Augusto

Corso di Porta Vittoria

10 ►

Corso Italia

Via Francesco Sforza

Piazza della Vetra

23

Corso di Porta Romana

26

22

3 ►

Cool Restaurants

Size: 14 x 21.5 cm / 5 1/2 x 8 in.
136 pp
Flexicover

c. 130 color photographs
Text in English, German, French,
Spanish and (*) Italian

Other titles in the same series:

Amsterdam (*)
ISBN 3-8238-4588-8

Barcelona (*)
ISBN 3-8238-4586-1

Berlin (*)
ISBN 3-8238-4585-3

Hamburg (*)
ISBN 3-8238-4599-3

London
ISBN 3-8238-4568-3

Los Angeles (*)
ISBN 3-8238-4589-6

New York
ISBN 3-8238-4571-3

Paris
ISBN 3-8238-4570-5

Tokyo (*)
ISBN 3-8238-4590-X

To be published in the
same series:

Brussels
Chicago
Geneva
Madrid
Miami
Moscow

Munich
Rome
Stockholm
Sydney
Vienna
Zurich

teNeues